IMAGES
of America

CARVEL
ICE CREAM

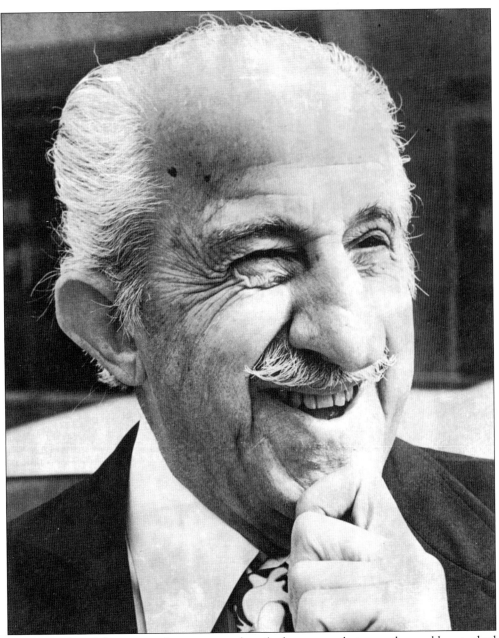

Best remembered for a voice that was once described as a cross between the marble-mouthed gravel of Marlon Brando's character in the *The Godfather* and the lovable, cowardly lion in *The Wizard of Oz*, Tom Carvel was the founder of Carvel Ice Cream and the creator of the world's best soft serve ice cream. Carvel started the brand that remains one of the most recognized and best loved names in the industry.

ON THE COVER: This image depicts the all-glass storefront of one of the original Carvel Ice Cream locations. The photograph was provided by the Carvel Corporation.

IMAGES
of America
CARVEL
ICE CREAM

Lauren McGowen and
Jennifer Dempsey

ARCADIA
PUBLISHING

Published by Arcadia Publishing
Charleston SC, Chicago IL, Portsmouth NH, San Francisco CA

Printed in the United States of America

Library of Congress Control Number: 2008932187

For all general information contact Arcadia Publishing at:
Telephone 843-853-2070
Fax 843-853-0044
E-mail sales@arcadiapublishing.com
For customer service and orders:
Toll-Free 1-888-313-2665

Visit us on the Internet at www.arcadiapublishing.com

*This book is in honor of Carvel Ice Cream's 75th anniversary
and is dedicated to the many generations of franchisees and
consumers who love and share the Carvel brand every day.*

CONTENTS

FOREWORD

When I started working for Carvel in 2002, my plan was to learn the procedures, operations, and systems that would make the brand continue to thrive. I anticipated my first few months on the job would consist of the typical in-store training, a financial evaluation, and a marketing overview. What I did not expect was the cultural and emotional training that consisted of reading through binders full of archived articles, seeing Carvel's presence in the Smithsonian Institute's American History Museum, and hearing franchisees' stories from Carvel's earlier years. The more I immersed myself in the brand, the more emotionally invested I got. I quickly realized that a major part of leading the Carvel brand was going to be preserving its legacy and the attributes that make it uniquely Carvel.

Tom Carvel was a man who blazed his path. He was not afraid to try different things and fail along the way. He was also not afraid to succeed and allow others to join him. He enabled those who wanted to follow in his path to do so through franchising. He never stopped innovating and always had his eye on the horizon. He connected with customers in a way that marketers have gone on to emulate for years. His commitment to excellence was unwavering and infectious. Tom Carvel created something special and there is no doubt about that, but it was the passion he instilled in his franchisees that have kept it alive all of these years.

When I started with the company, I met with a handful of franchisees who had been with Carvel for 30, 40, or even 50 years. I was and am amazed by their continued enthusiasm even during hard economic times, despite changes in the industry and while new competitors continue to pop up all around them. They genuinely believe in Carvel's unmatched quality and experience, and so do their loyal guests.

Upon meeting and reading letters from Carvel customers, I can see why franchisees have remained encouraged all of these years. Carvel is a brand that has been more than meaningful to generations of people. It has been the centerpiece of their most memorable birthdays, anniversaries, and even weddings. It has been the family ritual that has been passed down over the years and the weekly routine for the oldest of friends. Whatever the reason, the taste of Carvel conjures up the sort of nostalgia that literally puts a smile on your face. It has become crystal clear to me why so many people have made a special place in their hearts for Carvel.

Preserving all that is special and wonderful about the Carvel name is my goal every day. I have the utmost respect for the franchisees and the customers who have kept this brand so pure and sacred in a way that is honest, genuine, and unrivaled for so many years. As you read about the history and the stories, I hope you enjoy them as much as I did.

—Gary Bales,
President of Carvel

ACKNOWLEDGMENTS

Many who work for the Carvel Corporation wear the logo proudly on a daily basis throughout the United States. Without fail, each time they wear the name "Carvel," these employees are stopped by everyday people eager to share all of the reasons why they love Carvel Ice Cream. From stories about their Carvel-sponsored Little League teams, to their best Tom Carvel impression, to their favorite birthday, those in the famed logo shirt have heard it all. Their stories and passion for the brand inspired the Carvel Corporation to share the brand story. With a long history that has moved and inspired generations of ice cream lovers, the Carvel Corporation knew it was time to put all of their best memories and moments into one place.

The book is intended to acknowledge Carvel's place in American history and to recognize the franchisees, the customers, and, of course, the Carvel family that made the Carvel name what it is today.

The Carvel Corporation compiled images and information for this book from the Smithsonian Museum archives, news articles, Carvel family members, franchisees, and customers.

A special thanks to the franchisees who have made Carvel Ice Cream a part of their family. Thanks also to the Townsend family, who graciously shared their family history, including many of the images found in this book. The contribution they made to this book was significant by way of images and stories from the past.

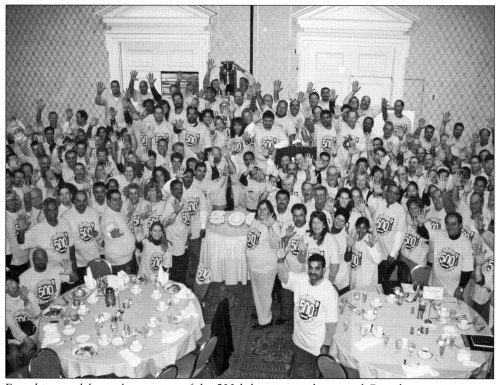

Franchisees celebrate the opening of the 500th location at the annual Carvel convention.

INTRODUCTION

This book is a pictorial sketch of one of America's most beloved companies, Carvel Ice Cream—a company that has created millions of memories for over three generations of consumers; a company that has created a once-in-a-lifetime opportunity for thousands of entrepreneurs; a company that prides itself on making fresh ice cream daily; and a company that was created by a young Greek immigrant who truly lived the American dream.

Tom Carvel was born in 1906 in Athens, Greece, to parents Andrew and Christina. Recognizing that America was truly the land of opportunity, the industrious couple moved Tom and his siblings to a Stratford, Connecticut, farm a few years later. Whether it was raising chickens in coops they built themselves or working in fields picking tomatoes, potatoes, or string beans for $1 a day, the Carvel children learned early on the importance of hard work.

When the family moved to New York's Lower East Side, Andrew, a chemist, earned "just enough to keep the family ticking over." Shoes and clothing were handed down from the oldest to the youngest child, and everyone understood the value of a dollar. Bitten by poverty, Tom ultimately left his chemistry studies at Textile High School to earn a living and help his family. He tried his hand at a lot of things: a shoeshine boy then promoted to manager; a newspaper delivery person; a test driver for Studebaker automobiles; and a vaudeville hoofer. He even took a crack at semipro football, sold radios and appliances, worked as an auto mechanic, and tried his hand as a Dixieland drummer.

Regarding his not-so-budding musical career, Tom once commented, "When I missed two meals in a row, I knew music wasn't my forte." However, throughout his life, Tom kept a drum set in his home and was known to entertain many a guest.

Then at age 26, a doctor discovered a tubercular spot on Tom's lung. In Tom's words, "In those days, TB was dreaded, more dreaded than cancer. If you had TB, that was it, brother." After doctors told him he had only three months to live, Tom decided fresh air and country living might help, so he borrowed $15 from his future wife, Agnes, built a frozen custard trailer, and peddled ice cream and hot dogs at fairs and exhibitions around New York.

Then in 1934, a flat tire on his trailer changed his life.

I've been in the right place at the right time. And lucky.

Memorial Day weekend, Tom loaded his trailer with frozen custard, which he bought already prepared and kept firm through the use of ice salt. On this unusually hot day, Tom was cruising through Hartsdale en route to Kensico Dam, a tourist attraction north of White Plains, when he heard an explosive noise. It was a flat tire. Pulling off the road, he parked his trailer next to a pottery stand and prayed the hot sun would not melt his product before he had a chance to get rid of it.

Much to his surprise, droves of cars pulled off the busy highway to his "roadside" stand, and customers expressed their delight in Tom's "soft" (melting) ice cream. Before long, Tom had served enough frozen custard to earn almost $60, which quickly convinced him that a roadside stand, if properly operated, could be a profitable venture.

With the kindly potter's permission and the promise to pay him when he could and help him sell pottery when he couldn't, Tom hooked into the pottery store's electricity, planted a few evergreen shrubs around his trailer, and set up shop. He personally provided curb service to customers and doubled as a salesman behind the counter.

Just two years later, Tom took over the pottery store and converted it into a frozen custard stand that remains in existence 75 years later. He bought a used freezer for $400 so he could control the

making of his own product; hired attractive girls who offered traveling motorists fast, courteous, and efficient curb service; and quickly built a business that grossed $6,000 a season.

The quality of the product is only as good as the machinery that produces it.

While working in the Army Post Exchange stores in Fort Bragg, North Carolina, during World War II, Tom began a thorough investigation into the mechanical features of many popular ice cream freezers. Most of them, he discovered, were converted batch machines. Having owned both new and old, he was fully aware of their shortcomings and decided to develop a freezer of his own.

Working alongside his brother Bruce, Tom finally came up with an improved freezer that could control the production of the product from a single cone to several hundred. His customized freezing system incorporated extra-sharp blades that scraped instantly frozen, minute ice cream crystals from the walls of a short barrel. The smooth, creamy product was pushed to the front of the barrel and released by the operator through the tip. Translated in terms of dollars and cents, his improved machine could produce ice cream with no waste whatsoever and without any pre-storage of any products. Satisfied with his device, Tom began to manufacture and sell his machine under the trade name of Custard King. His invention ultimately became the first of more than 300 patents, copyrights, and trademarks that he initiated.

We are a family business. It takes hard work and good people to run a successful Carvel store, and we're in favor of both.

After learning that many of his machine's purchasers were having trouble making payments, Tom began an intense investigation to learn why. He found that the operators were careless in their selection of their locations, often disregarded cleanliness, and worked only when the mood seemed to strike them. In addition, instead of concentrating on the profitable frozen custard product, others invested heavily in restaurant equipment and tried to sell additional food items.

After Tom summed up these deficiencies, he quickly realized that he could sell not only his machinery, but his expertise as well. Developing a franchised store plan in 1947 in which he lent his name, guidance, and careful supervision, Tom's quest ultimately led him to be called the "father of franchising."

For a flat fee and a percentage of the profits, Tom quickly began selling fully equipped stores, but only to people who had good sites with good potential. Tom personally trained the owners and supplied the store with all the initial equipment. The owners would use his trademark, and he would supply them with all they required to run their business. But they had to put their heart and soul into it; he could make no guarantees without these two critical elements.

In Tom's words, "The keys to success in the franchising business are a good product, manufactured according to a tightly guarded formula requiring absolutely fresh dairy products. I don't intend or try to guarantee that an owner will succeed under the Carvel trademarks. His/her success is entirely dependent upon their ability to run a business and not the ability of the trademark to do business."

Tom's philosophy worked like a charm as franchisees opened over 25 stores by the early 1950s.

I didn't sound pretty. But I got people's attention.

The distinctive voice of Tom Carvel coming from the radio stopped many a listener in his tracks, and that was its purpose. Aptly considered one of New York's most effective promoters, whether anyone wanted to admit it or not, Tom's commercials were once described as "kidnapping the ears of a nation," "sounding like a thousand fingernails scratching a blackboard," and "a voice terrible, yet mouthwatering."

In the 1950s, when Tom put one of his first stores in New York City, the radio announcers did not get the live advertisement right. Livid because the advertisement was calling customers

to this store's grand opening celebration, he infamously declared, "How hard is it to screw up a commercial?" So the next time, Tom took the microphone and started the company tradition of unrehearsed advertisements.

By his own account, Tom claimed that his diction and grammar were deficient. And that's just the way he liked it, because he believed that people didn't pay attention to slick announcers with clear voices. "If you say 'uh, uh, uh' people relate to that," he once claimed. It was also customary for the sound quality of the commercials to be awful, recorded on location by Tom himself with his portable tape recorder or video camera.

Even more, Tom was known for featuring franchisees in his commercials. Many of them did not know the English language well, and if they did, they were often so nervous that they were incoherent, giving at best one-word answers to Tom's leading questions about the high quality of the ice cream and its on-premises manufacturing process.

For the next 30 years, Tom made himself one of the most recognizable voices in broadcasting history. His ineptitude ultimately led to what every advertiser dreams of: instant and unmistakable brand awareness.

> Ask me if America is still the land of opportunity for industrious people, and my response is, "You're damned right it is."

Tom Carvel was the personification of the American dream. He was a man who was not afraid of hard work and did what it took to make his "rags to riches" story come true. Despite his engaging manner, twinkling blue eyes, neatly trimmed handlebar mustache, and friendly face, Tom was a tough and honest businessman who demanded only the best from those who worked with him. It's what his father would have expected.

"If I had not achieved my goal, I would have felt guilty," Tom once said. "For my father's purpose in bringing his children to America would have been defeated. He may have been poor financially, but he was by far the richest man in the world in spirit and goodwill."

This book captures many of the timeless moments along Tom's journey and showcases a company that introduced many imaginative and innovative ideas. From the concept of franchising to unique marketing and advertising approaches to multiple equipment and small wares patents and trademarks—not to mention the freshest premium ice cream on the market—the company that started with a flat tire has become one of the best loved and most recognized names in its industry.

After 75 years, Tom's vision of the "world's greatest soft serve" ice cream is still going strong. With courage, determination, and fortitude, this Greek immigrant gave a purpose to thousands of entrepreneurs around the world and, in turn, created millions of timeless memories and dedicated fans.

One

FOUNDER TOM CARVEL

Brands are born everyday, but seldom does the public know the founder as intimately as so many know Tom Carvel. As the first company founder to be featured in his own advertisements, his face and his voice were highly recognized across America, although it was more than a voice that led to Tom's success. It was his passion, his tireless effort, and his dream. Like many who have achieved the American dream, Tom Carvel's beginnings were humble. From a poor immigrant to the owner of a multimillion-dollar ice cream franchise, Tom Carvel made his way and never took his eye off of the prize. A loving and loyal family man and savvy yet strict businessman, Tom founded his fortune on a flat tire. While he was best known for his work to the general public, to his friends and family, he was so much more. Tom was a musician, the host of wonderful parties, the employer to many of his family members, and even the best man in his nephew's wedding. Tom and his wife, Agnes, did not have children, but he had six siblings, many of whom had children of their own. In many ways, Carvel's family extended far beyond those who are blood related. For the many loyal customers who share the love for ice cream, Tom Carvel became a part of their family.

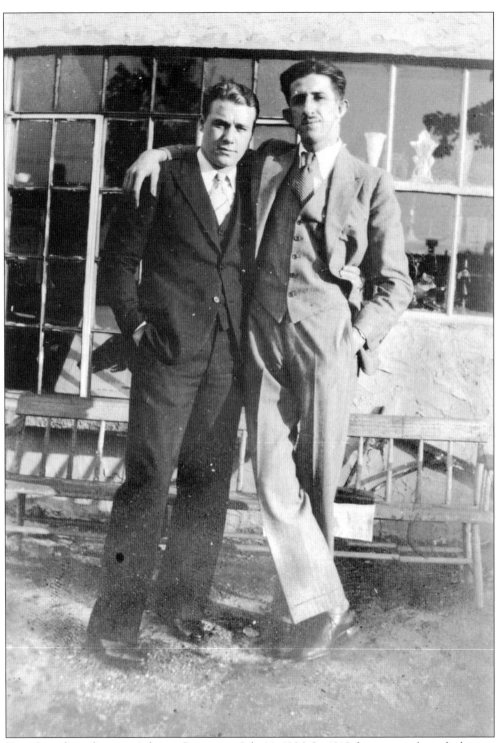

Tom Carvel was born in Athens, Greece, on July 14, 1906. In 1910, his parents brought him to Stratford, Connecticut, and they settled in New York City in 1920. Here Tom stands to the right of his friend in New York several years later.

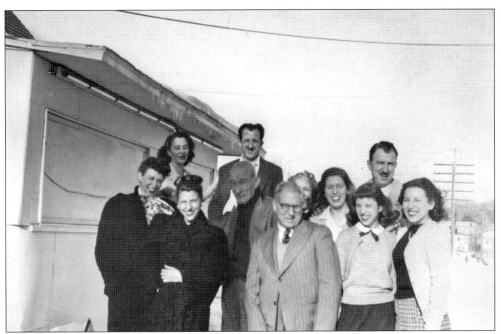

Tom's father, Andrew, was a chemist and wine specialist who helped support his family during Prohibition by restoring fermented wine for Greek restaurant owners. In this picture, Tom (standing in the back above the others and his father (directly in front of him) pose with family.

Tom's father was an inspiration throughout his life, instilling the values of hard work, sense of family, and heritage into his heart. The Greek songs his father would sing and play on the guitar created fond memories for young Tom. This 1947 image shows Tom's father, Andrew, with his granddaughter (Tom's niece) Diana Scourby.

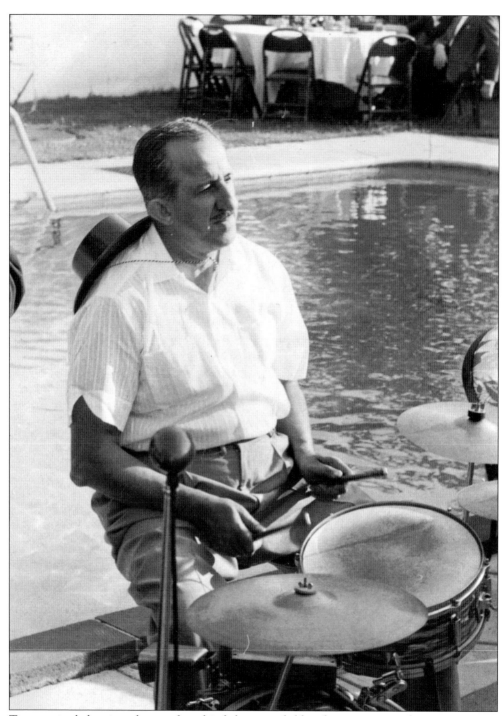

Tom received chemistry lessons from his father as a child and went on to study science in prep school, although he dreamed of becoming a famous drummer. He felt he had a unique talent that he brought to the seven-man Dixieland Band. Tom continued to play the drums long after he began his ice cream career. He would have annual parties at his house where he was known to play from time to time. At his party in October 1958, he plays the drums for the camera.

Tom was one of seven children in his family: four boys and three girls. When they came to the United States, their ages ranged from 2 to 12 years old. Their father, Andrew, arrived in America first before the rest of the family joined him and settled there. This photograph was taken many years later at Tom's house. From left to right are Peter Pappas; Anthea Pappas (Tom's sister); Tom's mother, Christina (seated center); Tom; Angeliki Rapti (Tom's aunt, seated on the right); and Tom's wife, Agnes.

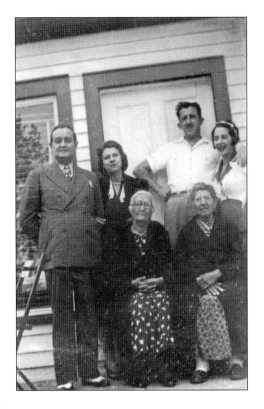

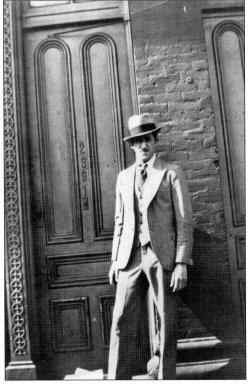

A jack of many trades, Carvel held several jobs before discovering his passion for ice cream. In the early 1930s, Tom poses for this photograph while on business in Manhattan.

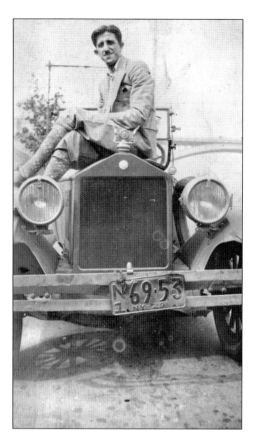

He did a bit of everything from selling radios and automobiles to test driving Studebakers. Here Tom poses with an old Ford model in 1929.

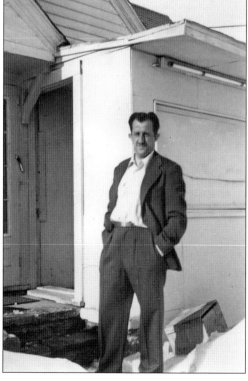

Doctors found what they believed to be tuberculosis on Tom Carvel's lung when he was only 26 years old and informed him that he only had three months to live. He opted for a simpler life and headed to Westchester County in New York.

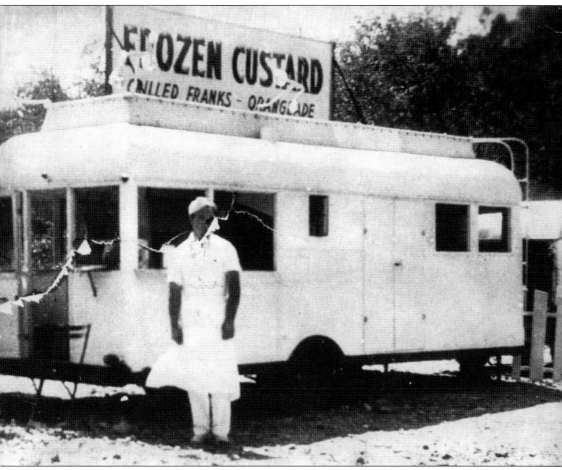

It was from there that Tom built a small house trailer, which he hitched to a Ford Model A. He began to sell custard at fairs and festivals out of his small trailer. On a Friday afternoon, he set off for Kensico Dam, north of White Plains, New York. He was on Central Avenue in Hartsdale, New York, when one of the trailer tires blew out.

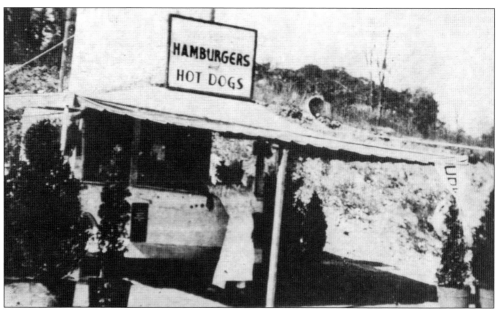

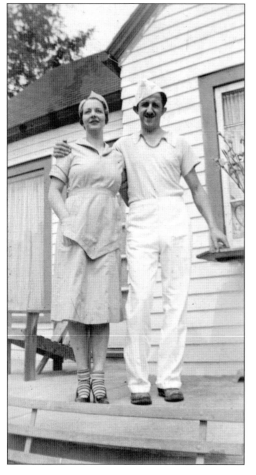

He had no tools, and there was no help in sight. He sat for a moment and prayed, and shortly after, he was approached by a burly gray-haired man named Pop Quilan. Quilan owned the pottery store nearby. He helped Carvel pull the trailer into his yard and allowed him to hook into the pottery store's electricity. With no money to fix the tire, and a feeling that a fixed location may be better than traveling from town to town, Carvel soon called the parking lot home.

Gradually the ice cream business picked up. During the slow times, Tom would tinker with machinery in the back of the pottery shop. He served as a refrigeration consultant and concessionaire at Fort Bragg, North Carolina, during World War II. There he honed his skills and expertise in refrigeration. Eventually his tinkering led to patents that helped build his business.

In his first year, Carvel grossed $3,500 working out of the trailer in the pottery shop's parking lot. The following year, he leased the pottery shop for $100 and converted the trailer into a frozen custard stand complete with a secondhand freezer that enabled him to make his own custard. That year, he grossed $6,000. Tom ultimately purchased the old pottery store in 1936, and it became the first official Carvel location. Here Tom stands with his brother Bruce and his mother, Christina, in front of the Hartsdale, New York, location.

Throughout his career, his family remained a vital part of his success. Bruce Carvel, Tom's brother, is having fun skiing in this photograph, although he spent a great deal of his time assisting Tom with constructing and conceptualizing ice cream machinery.

Here family members gather for a photograph at Tom's house in 1950. Tom's sister Florence stands in a black dress behind her father, Andrew, who is seated. Beside Florence is Tom's brother Bruce, who is wearing a tie. His sister Anthea is to the left of Bruce, and Tom Carvel stands on the far right.

Tom's brother Jerry and sister Anthea visit Tom's house in New York in 1954.

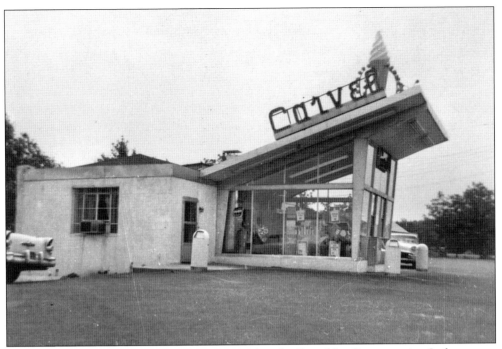

Many of Tom's family members held positions within the Carvel Ice Cream empire. In fact, many owned stores themselves. Tom's sister Anthea and her husband, Peter Pappas, took this photograph of their location in Sayreville, New Jersey, in 1957.

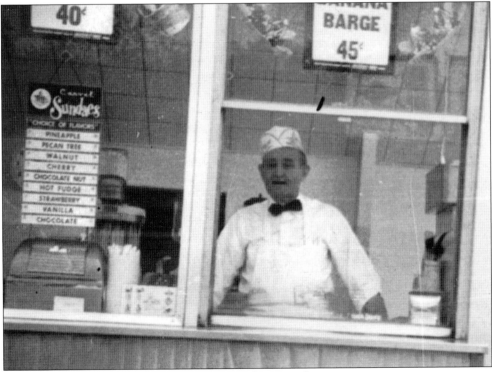

Here Peter Pappas is working inside of his store that same day.

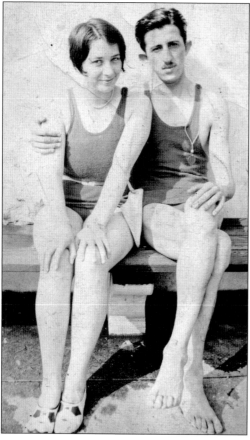

Three generations are represented in this 1939 photograph. From left to right are Dorthea Pappas; her mother, Anthea (Carvel) Pappas; and Christina Carvel, mother of Anthea. Beside Christina Carvel is Tom's aunt Angeliki Rapti.

Tom also contributes much of his success to the love and support of his wife, Agnes. He often referenced her $15 contribution to him as the launching pad of his ice cream career. Here he is with his bride-to-be at the beach not long after they met.

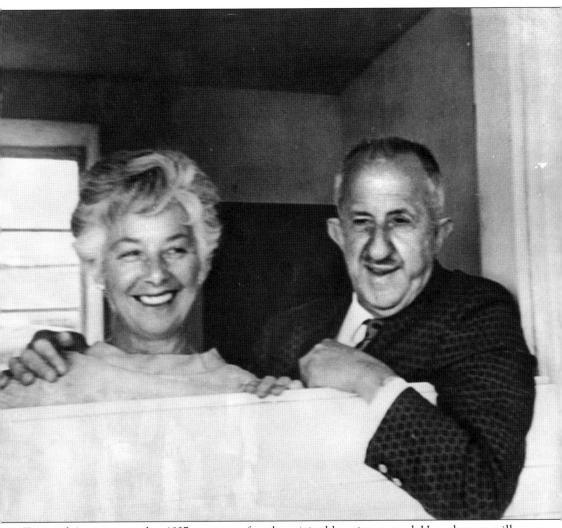

Tom and Agnes married in 1937, one year after the original location opened. Here they are still in love many years later.

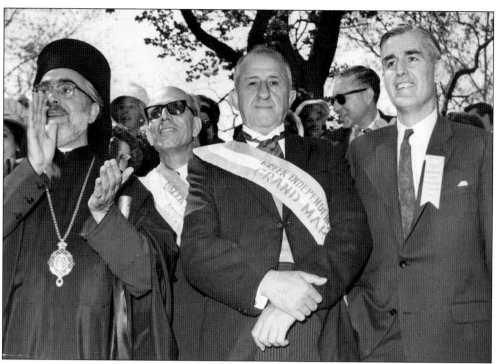

Tom took great pride in his family and in his heritage. One year, he was invited to be the grand marshal at the Greek Independence Day Parade in New York City.

The News

Hartsdale, N.Y. MAY 2, 1957.

Horatio Alger Award To Carvel

The Horatio Alger award presented each year to a limited number of men who contributed to and exemplify the American Free Enterprise System, will be given to Thomas A. Carvel, of

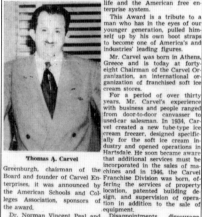

Thomas A. Carvel

Greenburgh, chairman of the Board and founder of Carvel Enterprises, it was announced by the American Schools and Colleges Association, sponsors of the award.

Dr. Norman Vincent Peal and David Sarnoff, former winners and national chairmen, will present this award for "living proof" of the opportunities in our American way of life" and "initiative, ambition, love of freedom and integrity" to Mr. Carvel.

Mr. Carvel will receive the Award, May 9, at the Waldorf-Astoria's Empire Room, where the press of the nation and such former winners as Bernard Baruch, Charles E. Wilson, Allen B. Dumont, Conrad Hilton, Milton Eisenhower and Dr. Ralph Bunche have been invited to be on hand to watch the official presentation of the Award and the first decade of Horatio Alger winners.

The winners of the Award are selected by the votes of thousands of high school and college youngsters throughout the country, voting on the background of the man and what they feel he contributed to the American way of life and the American free enterprise system.

This Award is a tribute to a man who has in the eyes of our younger generation, pulled himself up by his own boot straps to become one of America's and industries' leading figures.

Mr. Carvel was born in Athens, Greece and is today at forty-eight Chairman of the Carvel Organization, an international organization of franchised soft ice cream stores.

For a period of over thirty years, Mr. Carvel's experience with business and people ranged from door-to-door canvasser to used-car salesman. In 1934, Carvel created a new tube-type ice cream freezer, designed specifically for the soft ice cream industry and opened operations in Hartsdale. He soon became aware that additional services must be incorporated in the sales of machines and in 1946, the Carvel Franchise Division was born, offering the services of property location, patented building design, and supervision of operation in addition to the sale of equipment.

Disappointments, discouragements and failures overcome by experience, courage and perseverance make Carvel's a typical American Success Story.

Today, the Carvel organization with its present offices in Yonkers, creates employment for thousands of people and stimulates the growth of a new young ind

In 1957, Tom was awarded the Horatio Alger Award. Each year, a committee selects six or seven Americans whose careers exemplify initiative, hard work, honesty, and traditional American ideals. A book was published by the Horatio Alger Committee called *Opportunity Still Knocks* with a bio of the winners, intended to show young Americans "living proof" that the American dream does still exist. Tom also founded and funded the annual Carvel Immigrant Entrepreneur Award that honors outstanding immigrant entrepreneurs whose success embodies the American dream.

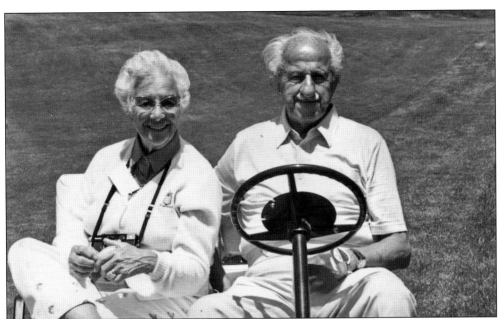

Later in life, when Carvel was making a name for itself, Tom and Agnes set up the Carvel Foundation, which would enable them to give back to the communities they serve. The foundation is still around today. Additionally, they built Carvel Country Club, where members of the community could gather, golf, and relax. Here Tom and Agnes enjoy an afternoon ride through the Carvel Country Club in 1977.

Tom also dabbled in other businesses, including manufacturing, vitamins, and hamburgers. He attempted to create another franchise concept called Hubie's, or H-Burger, but the concept never grew.

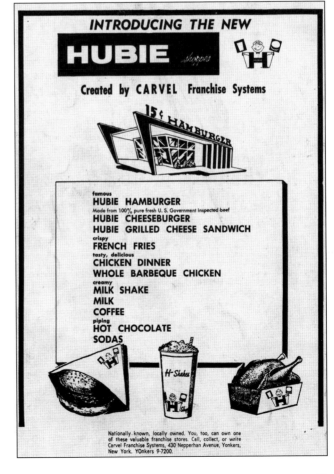

INTRODUCING THE NEW

HUBIE *shoppes*

Created by CARVEL Franchise Systems

15¢ HAMBURGER

famous
HUBIE HAMBURGER
Made from 100% pure fresh U. S. Government Inspected beef
HUBIE CHEESEBURGER
HUBIE GRILLED CHEESE SANDWICH
crispy
FRENCH FRIES
tasty, delicious
CHICKEN DINNER
WHOLE BARBEQUE CHICKEN
creamy
MILK SHAKE
MILK
COFFEE
piping
HOT CHOCOLATE
SODAS

H-Shakes

Nationally. known, locally owned. You, too, can own one of these valuable franchise stores. Call, collect, or write Carvel Franchise Systems, 430 Nepperhan Avenue, Yonkers, New York. YOnkers 9-7200.

After several attempts to find his perfect path—from musician, to mechanic, to concessionaire—Tom found it was ice cream that enabled him to forever leave his mark on America. In 1989, only one year after selling Carvel to Investcorp, Tom Carvel died in his sleep at age 84.

Tom was survived by his beautiful wife of 53 years, Agnes. She died in 1998 at age 89.

Two

THE BIRTH OF A BRAND

According to American history, the nation's first ice cream shop opened in New York in 1776. Today over 90 percent of households indulge in ice cream. It has been around for ages and somehow never gets old. Ice cream shops are thought to be recession resilient because they allow people to indulge without spending a great deal of money. Even during times of economic pressure, people will not compromise their favorite treat. Shops that allow for guests to stay and chat and enjoy their "indulgence" create an occasion and an experience that people love, remember, and crave. Tom Carvel believed that ice cream was the most complete food around. In fact, he once said, "A baby lives entirely on milk so the human body can certainly live on ice cream, which is basically milk." He also didn't believe it was just for holidays; he thought people should have it for breakfast if they wanted. And that was the attitude that had him focused on creating the highest quality product on the market. While Tom did not claim to invent ice cream, he did claim exclusivity on premium soft serve ice cream. He tinkered with equipment constantly as well as the recipe to the ice cream in order to create the ultimate flavor. As Carvel's tag line suggests, "It's what happy tastes like." Tom knew ice cream was more than just a dessert; it was a gift that created memories. In cake form, it was the centerpiece of all special occasions. Therefore, he created character cakes for almost every holiday. Dad didn't get a "cake" on Father's Day, he got a "Fudgie the Whale," and fans agreed it was certainly more special. After all, it's not a party without a Carvel Ice Cream cake.

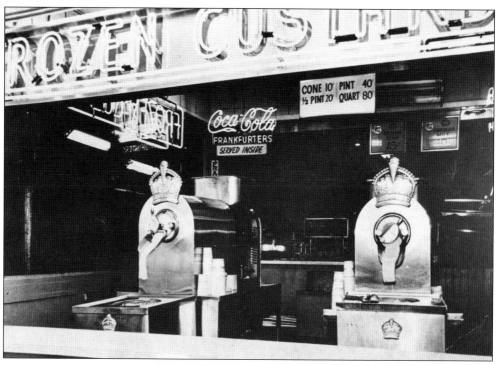

THE CARVEL DH 80X

Designed for maximum production, the heavy duty Carvel DH 80X, Carvel's current model ice cream freezer, provides Carvel owners with additional benefits in the form of reduced energy and labor costs.

Another innovative addition to the Carvel store package is the Carvel Roll-Hard Freezer, shown below, in position in front of the DH 80X. This versatile cabinet eliminates heat shock during the manufacture and handling of products, thus maintaining the smooth, creamy consistency of the ice cream as it comes out of the freezer. It is heat shock, or exposure to temperature variations, during shipping and handling which causes coarseness and crystallization in other brands of ice cream.

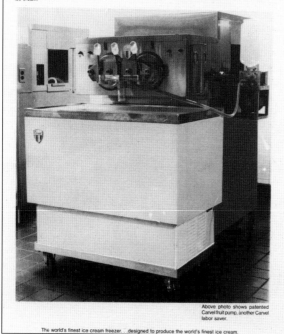

Above photo shows patented Carvel fruit pump, another Carvel labor saver.

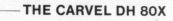

The world's finest ice cream freezer. . .designed to produce the world's finest ice cream.

Carvel Ice Cream began with several formulas and inventions that would be needed to create the ice cream that was uniquely Carvel. Among these were the secret ice cream formula and patented "no air pump" super-low temperature ice cream machine.

Tom was able to perfect an ice cream formula that could be sold as soft or hard ice cream using a special freezing system. In those days, this accomplishment was a rarity and enabled Carvel to produce premium quality ice cream. Shortly after, he designed the Carvel DH 80X, which was more energy and labor efficient, as well as the Carvel Roll-Hard freezer, which eliminated heat shock.

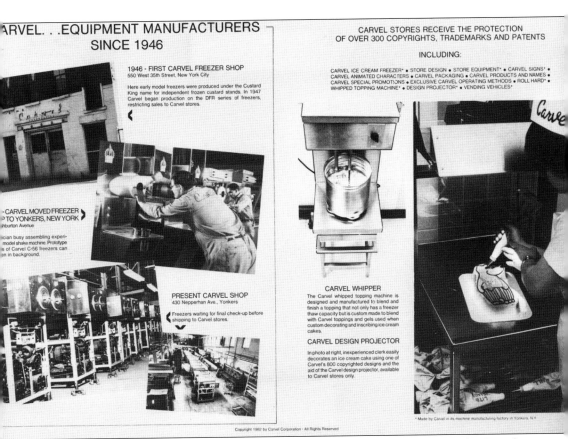

ARVEL. . .EQUIPMENT MANUFACTURERS
SINCE 1946

1946 - FIRST CARVEL FREEZER SHOP
550 West 35th Street, New York City

Here early model freezers were produced under the Custard King name for independent frozen custard stands. In 1947 Carvel began production on the DFR series of freezers, restricting sales to Carvel stores.

**- CARVEL MOVED FREEZER ▶
▶ TO YONKERS, NEW YORK**
ihburton Avenue

ician busy assembling experi-
model shake machine. Prototype
s of Carvel C-56 freezers can
an in background.

PRESENT CARVEL SHOP
430 Nepperhan Ave., Yonkers

◀ Freezers waiting for final check-up before shipping to Carvel stores.

CARVEL STORES RECEIVE THE PROTECTION
OF OVER 300 COPYRIGHTS, TRADEMARKS AND PATENTS

INCLUDING:

CARVEL ICE CREAM FREEZER* ● STORE DESIGN ● STORE EQUIPMENT* ● CARVEL SIGNS* ●
CARVEL ANIMATED CHARACTERS ● CARVEL PACKAGING ● CARVEL PRODUCTS AND NAMES ●
CARVEL SPECIAL PROMOTIONS ● EXCLUSIVE CARVEL OPERATING METHODS ● ROLL HARD* ●
WHIPPED TOPPING MACHINE* ● DESIGN PROJECTOR* ● VENDING VEHICLES*

CARVEL WHIPPER
The Carvel whipped topping machine is designed and manufactured to blend and finish a topping that not only has a freezer thaw capacity but is custom made to blend with Carvel toppings and gels used when custom decorating and inscribing ice cream cakes.

CARVEL DESIGN PROJECTOR
In photo at right, inexperienced clerk easily decorates an ice cream cake using one of Carvel's 800 copyrighted designs and the aid of the Carvel design projector, available to Carvel stores only.

* Made by Carvel in its machine manufacturing factory in Yonkers, N.Y.

All in all, Carvel held more than 300 copyrights, trademarks, and patents, including the Carvel Whipper, Carvel Design Projector, and the ice cream decorator tip that is still widely used in the industry today, to name a few.

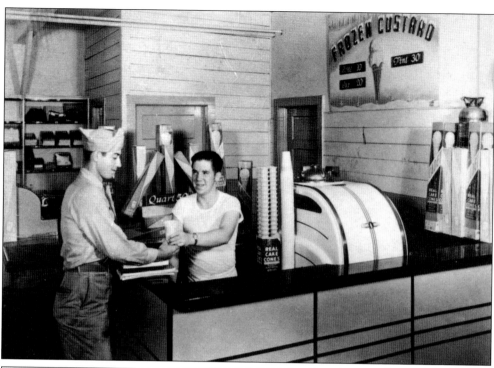

Carvel operated one of the first Carvel Ice Cream machines at the Fort Bragg Induction Center in 1942.

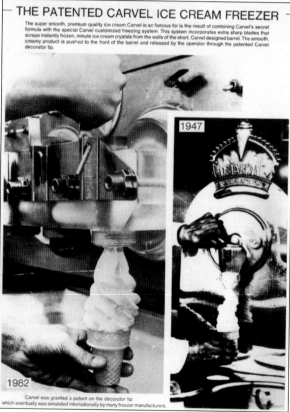

THE PATENTED CARVEL ICE CREAM FREEZER

The super smooth, premium quality ice cream Carvel is so famous for is the result of combining Carvel's secret formula with the special Carvel customized freezing system. This system incorporates extra sharp blades that scrape instantly frozen, minute ice cream crystals from the walls of the short, Carvel designed barrel. The smooth, creamy product is pushed to the front of the barrel and released by the operator through the patented Carvel decorator tip.

1947

1982

Carvel was granted a patent on the decorator tip which eventually was simulated internationally by many freezer manufacturers.

The first ice cream freezer manufactured exclusively for Carvel was created in 1947. Tom and his brother Bruce had an improved design that could produce $70 worth of ice cream cones in one hour without any waste whatsoever.

Tom began selling these freezers under the trade name "Custard King." In 1947 alone, he sold 71 machines at $2,900 each. That same year, he set up a formal manufacturing plant at 550 West Thirty-fifth Street in New York City to manufacture the patented Carvel Ice Cream machinery.

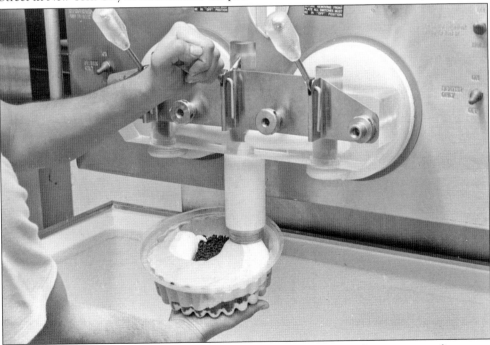

According to Tom Carvel himself, Carvel Ice Cream is "a customized, premium quality, super smooth, non-air pumped ice cream that has been formulated and balanced to sell as either soft or hard premium quality ice cream at quality prices."

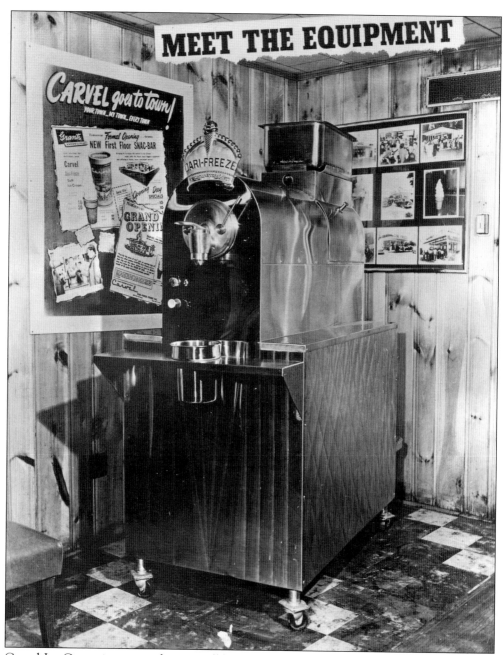

Carvel Ice Cream is processed in a small-barrel, no air pump, continuous, slow-speed freezing system. Only Carvel ingredients can make Carvel Ice Cream. The Carvel freezing system best functions with a specific combination of milk solids, cream, eggs, and stabilizers formulated specifically for Carvel.

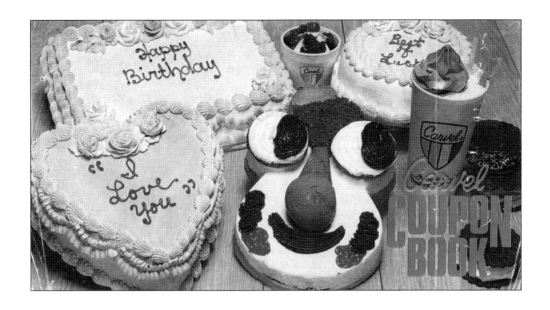

In Tom Carvel's day, there were more than 109 formula and flavor combinations of Carvel Ice Cream and over 500 exclusive designs, inscriptions, and molds.

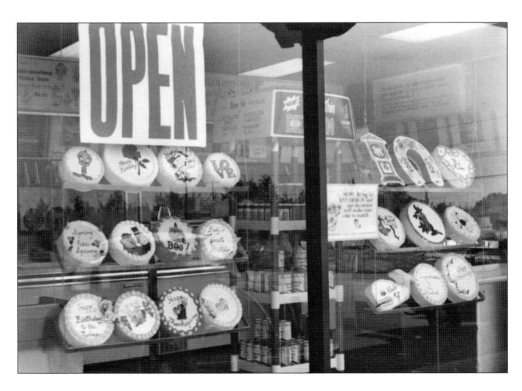

Throughout the years, franchisees
perfected the art of casting and icing
cakes and creating unique designs of
their own.

The "Freezy Pak," a clear plastic package to showcase the products, was born in 1950. At the time, Carvel was one of the only concepts in the ice cream industry that utilized plastic packaging.

Tom did not create the ice cream sandwich, but he did decide to make it round and give it a name that people would remember for years to come: the Flying Saucer. The name was trademarked in 1951, and it remains one of the best recognized and top selling ice cream novelties today.

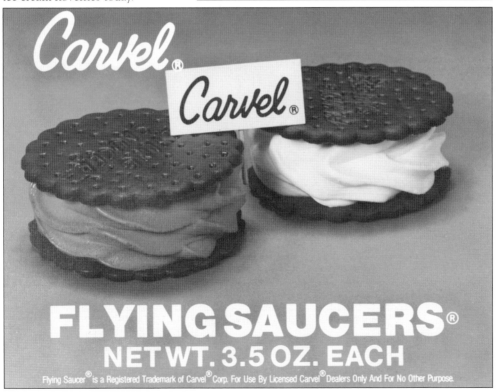

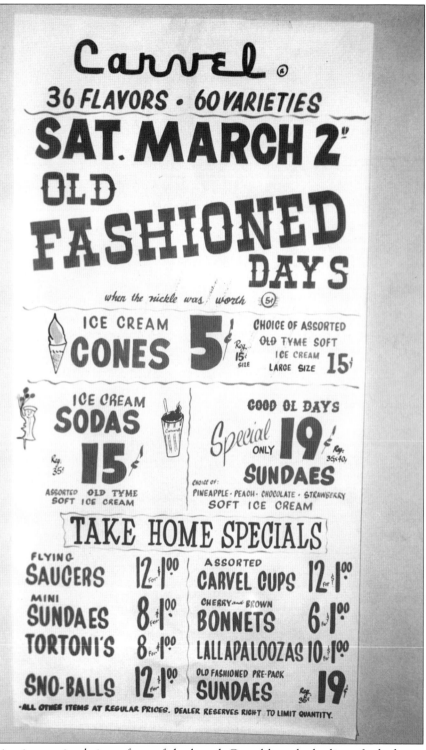

With packaging innovation being a forte of the brand, Carvel launched a line of take-home desserts in 1953.

To make Carvel Ice Cream cakes distinguishable not only in taste but also in form, Carvel began using exclusive cake designs to decorate cakes.

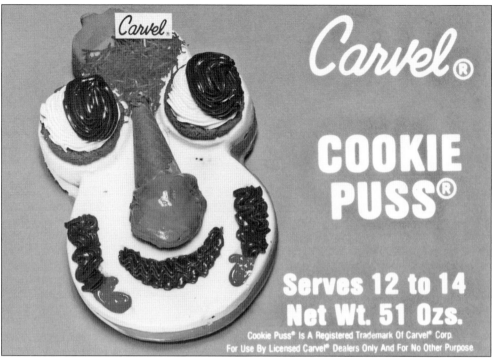

Cookie Puss, along with Fudgie the Whale and Hug-Me Bear, was one of the original birthday cake characters. Born on Planet Birthday, Cookie Puss is a space alien; his original name was "Celestial Person," and his initials, C. P., later came to stand for "Cookie Puss." Old television advertisements depicted Cookie Puss flying in a saucer-shaped spacecraft. Popular Carvel folklore, however, suggests Cookie Puss was meant to resemble Tom Carvel. Fudgie the Whale was a popular Father's Day cake often personalized to a "Whale of a Dad."

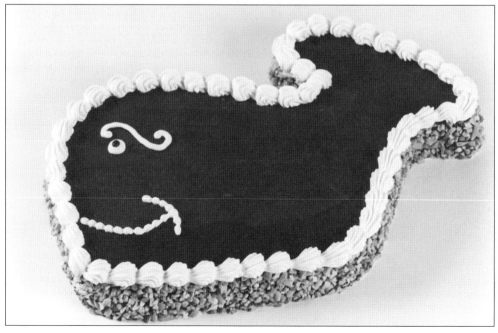

By 1968, Carvel had identified the need to have a line of kosher items that would later include all Carvel Ice Cream products.

In an effort to minimize waste, Tom experimented with the leftover Flying Saucer cookies, crumbled them up, and added a layer of cookie crunch to his ice cream cakes. The idea was a hit, and in 1972 the oh-so-famous "crunchies" were born.

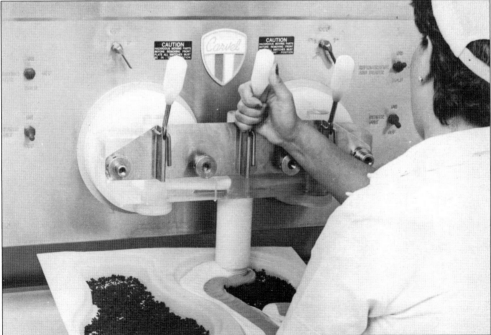

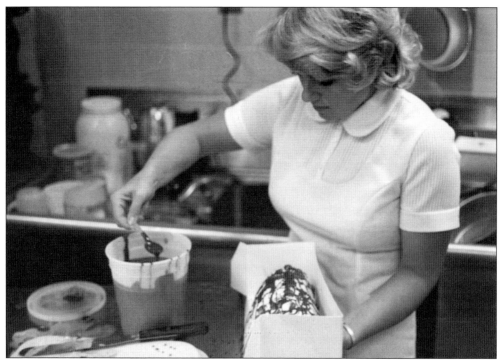

Carvel continued to introduce signature products that made the brand famous, including Carvelogs, Lollapallooza, Sundae Sticks, Sno-Balls, and Icy Wycys. Pictured here is a Carvelog in the making.

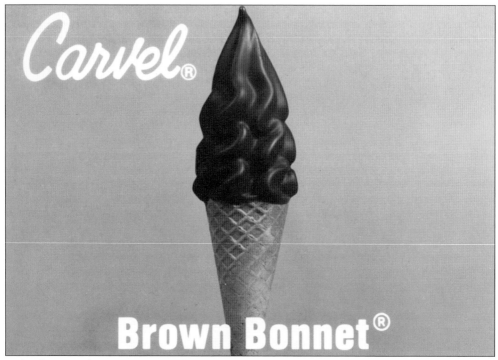

A fan favorite, the Brown Bonnet has delighted customers for decades.

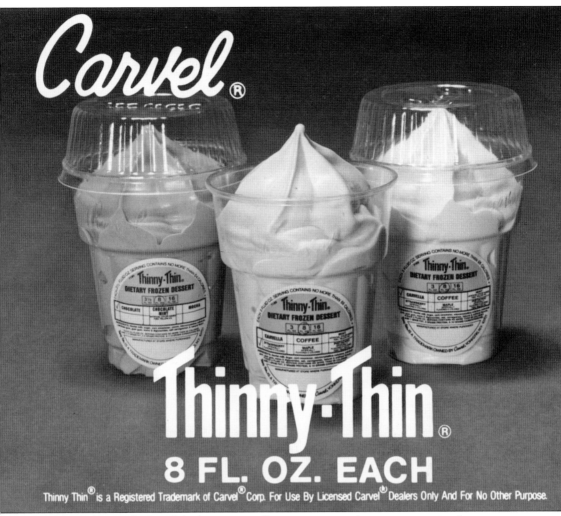

With several lines of rich and thick ice cream offerings, it was time to present an option for consumers who were watching their weight. In 1972, Carvel introduced the Thinny-Thin, a low-calorie, low-fat dietary dessert. In that year, they also introduced Lo-Yo, a frozen yogurt line.

Dumpy the Pumpkin®

I'M DUMPY THE PUMPKIN by *Carvel*®

Have -A- Happy

Net Weight 44 Ounces

Dumpy The Pumpkin®Is A Registered Trademark Of Carvel®Corp. For Use By Licensed Carvel®Dealers Only And For No Other Purpose

Before long, Carvel also had a unique cake for every holiday. A few of the original holiday cakes include Flower Basket for Mother's Day, Dumpy the Pumpkin and Nutty the Ghost for Halloween, Tom the Turkey for Thanksgiving, and a Snow Man for Christmas.

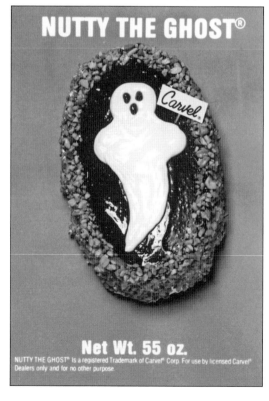

NUTTY THE GHOST®

Carvel®

Net Wt. 55 oz.

NUTTY THE GHOST® Is a registered Trademark of Carvel® Corp. For use by licensed Carvel® Dealers only and for no other purpose.

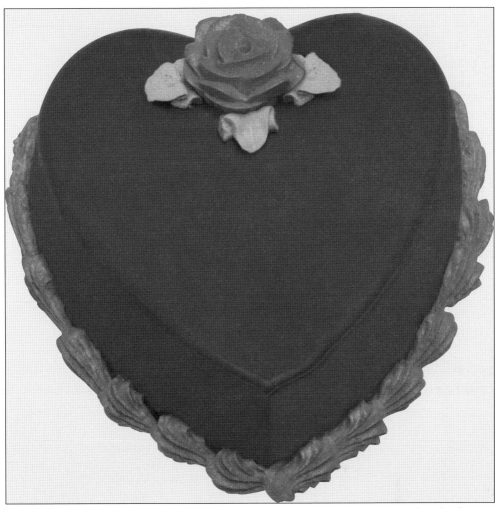

Innovation continued even after Tom Carvel passed. In 1998, Carvel introduced Lil' Love Cakes, which were a smaller version of the full round cake. A Lil' Love Covered Heart is pictured here.

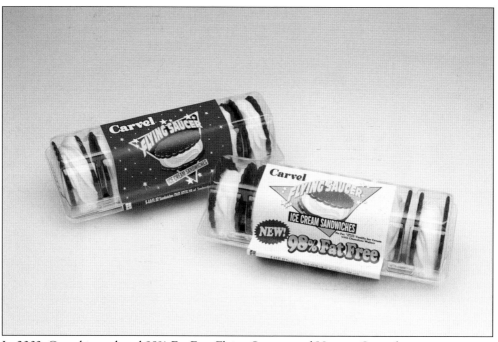

In 2003, Carvel introduced 98% Fat Free Flying Saucers and Uptown Smoothies.

In 2005, Carvel introduced Sundae Dashers, and in 2008 they expanded their beverage line with Arctic Blenders and Carvelattes. By the end of 2008, there were over 200 unique Carvel menu items.

Three

A MARKETING PIONEER

Companies spend billions of dollars annually to learn how to market and sell their products. How does a company reach its target customer? How does a company persuade a customer to take action and visit their store and buy their merchandise? Many believe in building brand trust, which will eventually equate to loyalty. Many attempt to speak their language and show interest in the things they are interested in through sponsorships and celebrity endorsements. Others try coupons, billboards, and banners that say "look at me" and "buy me." They are all seeking out the silver bullet, although it seems like the most success is found when it happens effortlessly. There was no mistaking that Tom liked to do things his own way. It was no surprise he took this approach with marketing. When he heard an advertisement for Carvel on the radio that he did not like, he decided then and there he could do it better himself—and he did. He used no lines and no prepared script. Tom would go on the air and improvise his radio and television advertisements. The amateur quality appealed to the everyday person, and the flaws made him relatable. He went on to create concepts in the advertising world that are still emulated today. Understanding that ice cream is about an experience, Carvel mastered staging events. From major grand openings to the Little Miss Half Pint competition, he knew how to get a town together to have fun.

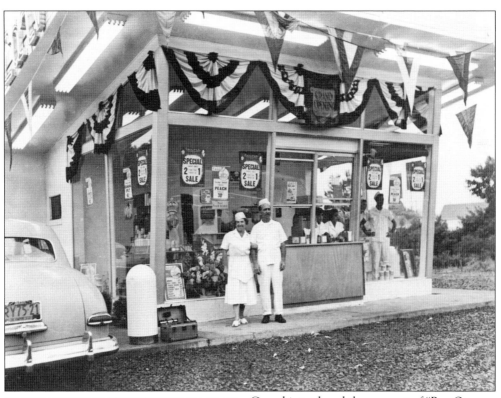

Carvel introduced the concept of "Buy One Get One Free" (also known as "Two for One"). Carvel believed the word "free" would cause a customer to spend time, money, and energy to drive to a Carvel store.

By 1948, the brand had quickly become known for popular daily, weekly, and weekend specials. Even today, Carvel locations honor the well-known "Buy One, Get One Free Wednesdays" where "Wednesday Is Sundae" at Carvel.

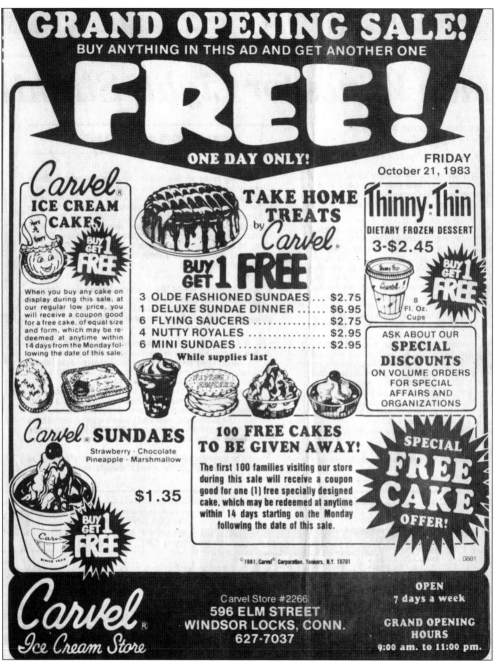

A few other specials or promotions that Carvel ran in print publications during the early years include Super Sale Days, Summer Spectaculars, and $2-off coupons.

Carvel. ICE CREAM CAKE SALE

SPECIAL FUND-RAISING PROGRAM FOR

LOCAL CHURCH, SCHOOL, CIVIC ORGANIZATIONS

Give...
And Enjoy

ICE CREAM **CAKE**

CUSTOM DECORATED FOR ANY OCCA-
SION . . . BIRTHDAYS, ANNIVERSARIES,
SHOWERS, ETC.

CARVEL CAKES ARE MADE WITH ICE
CREAM, EXCLUSIVE CAKE CRUNCH AND
WHIPPED TOPPING.

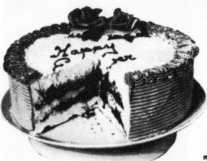

WE MAKE IT...AT CARVEL®

Carvel
ice cream is
made fresh daily
on the premises.

Choose from these sizes:

7" SERVES 8	$3²⁵	
8" SERVES 12	$4²⁵	
9" SERVES 15	$5²⁵	

10" SERVES 18	$6²⁵	
12" SERVES 30	$8²⁵	
10"x14" SHEET SERVES 24	$7²⁵	

Instructions:

- *SELECT SIZE CAKE DESIRED*
- *PAY AMOUNT INDICATED*
- *YOU'LL RECEIVE RECEIPT TO BRING TO STORE WHEN PICKING UP CAKE*
- *THERE IS NO TIME LIMIT—YOU MAY USE YOUR PAID RECEIPT ANY TIME*
- *WE SUGGEST YOU PHONE AHEAD SO YOUR CAKE WILL BE READY THE DAY YOU CHOOSE*

Carvel® **ICE CREAM SUPER MARKET**

36 FLAVORS - 60 VARIETIES

150 BAILEY at McKINLEY
Phone: 826-2877
OPEN 7 DAYS 11 A.M.-11 P.M.

Once Carvel began franchising, community outreach was something that was always preached to its franchisees. One tactic Tom Carvel made available to them was the Carvel cake sale fund-raiser. Local church, school, and charitable organizations can purchase Carvel cakes at a discounted rate and sell them to make a profit for their organization. This program is also still around today.

49

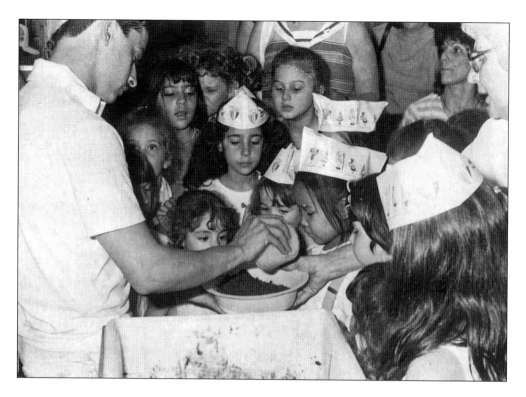

Franchisees were also encouraged to participate in local store marketing efforts. Many hosted class tours for children to give them a behind-the-scenes look at how fresh Carvel Ice Cream is made.

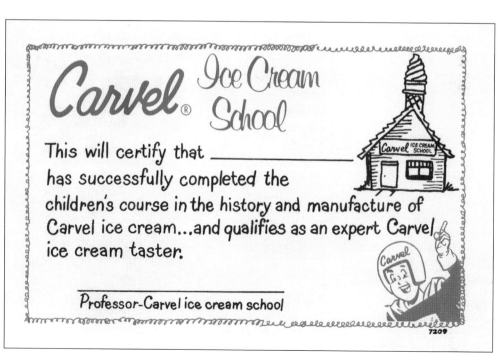

Call-a-Kake was a telephone ordering service where customers could call a toll-free number, and a cake of their choice along with a personalized greeting would be sent to the requested location. This Carvel favorite was a major sales driver and also a Carvel first.

In 1950, Carvel Ice Cream began advertising on television.

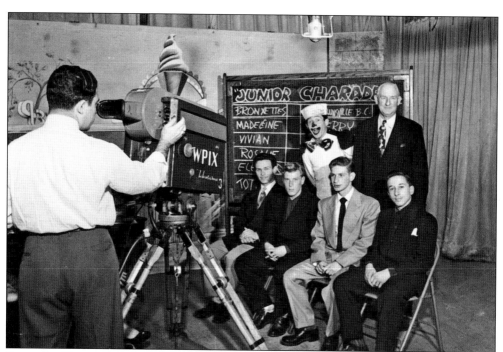

Freezy the Clown is known as the first clown ever used in fast-food promotion. Here he is featured on *Junior Charades*, a half hour program on WPIX, a news affiliate in New York. The exposure cost Carvel $600 at the time.

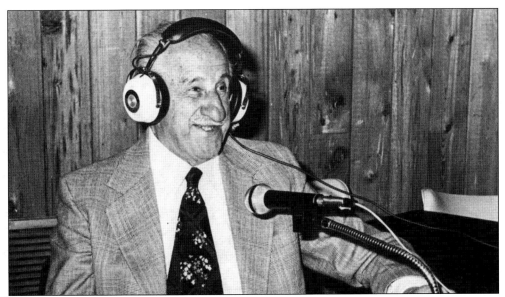

One of the major innovations that made Tom Carvel famous was his use of beyond-memorable television and radio advertisements. While driving in his car, Tom heard a radio advertisement for a new Carvel opening where the announcer neglected to mention the correct location. As the story goes, he was convinced he could do a better job, so he drove to the radio station and did the commercial himself. That launched an advertising campaign that featured improvised spots by Tom himself, full of errors and mumblings that he believed were endearing and relatable to his customers.

The first television advertisement he wrote and starred in was in 1955. Many of his advertisements were recorded in his own sound room in the Carvel Inn in Yonkers, New York.

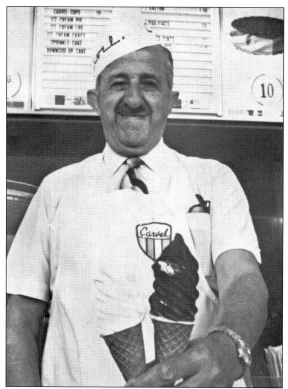

According to the *New York Times*, "Critics said he butchered diction and syntax and turned a 60-second commercial into a miniature comedy of errors that drove elocution teachers to distraction. But the commercials, which he narrated without a script and never edited for flubs, sold ice cream like no other tool."

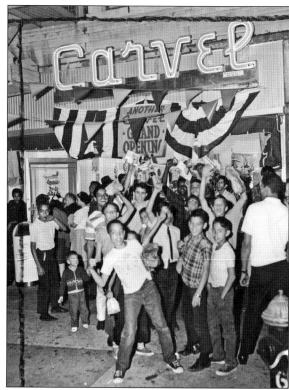

In response to criticism of his improvised commercials, Tom said, "our commercials are for people who look like us, talk like and sound like us."

In 1952, a young spaceman in a clear plastic space helmet called "Captain Carvel" introduced Flying Saucers, the newest ice cream novelty. The launch of the Flying Saucer was the first chain-wide advertising campaign that kicked off with "C-Day," also known as Children's Day.

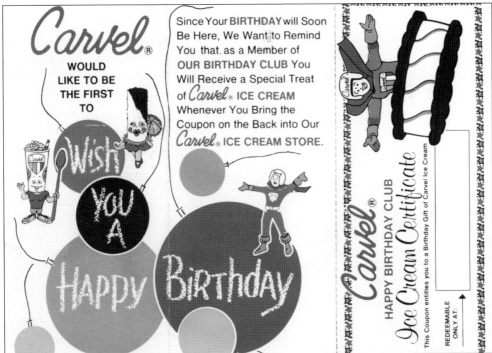

The introduction of gift certificates at Carvel was in 1954. One of the first was in association with the Birthday Club. Carvel would send a gift certificate to customers to redeem for their birthday.

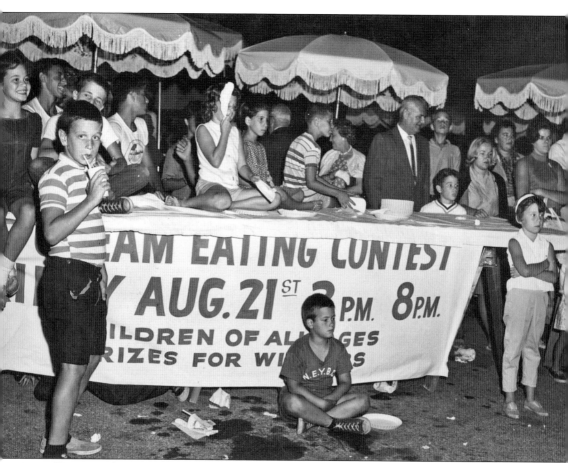

Tom Carvel even tried his hand at public relations. The company hosted an Ice Cream Eating Contest in which children of all ages could participate. This image is from the contest in 1951.

Stores would use flyers to promote the Ice Cream Eating Contests. These could be mailed or distributed at schools or at the store.

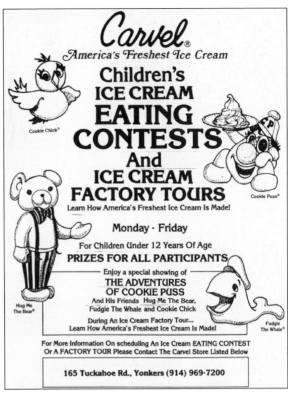

Enjoy a special showing of
THE ADVENTURES OF COOKIE PUSS
And His Friends Hug Me The Bear,
Fudgie The Whale and Cookie Chick
During An Ice Cream Factory Tour...
Learn How America's Freshest Ice Cream Is Made!

For More Information On scheduling An Ice Cream EATING CONTEST
Or A FACTORY TOUR Please Contact The Carvel Store Listed Below

165 Tuckahoe Rd., Yonkers (914) 969-7200

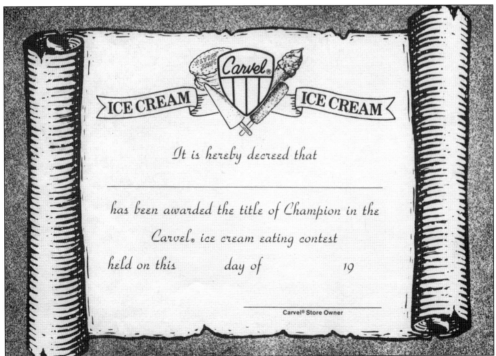

In addition to receiving free ice cream during the contest, the winner would receive an official award certificate from Carvel.

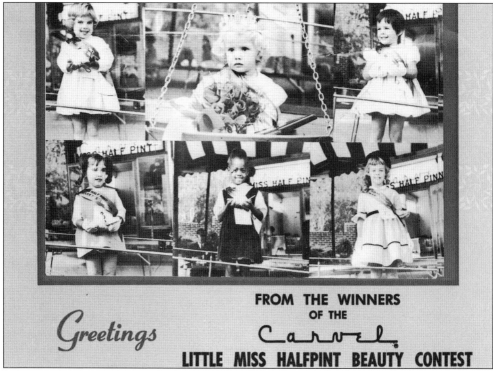

Greetings

FROM THE WINNERS
OF THE

Carvel

LITTLE MISS HALFPINT BEAUTY CONTEST

In 1959, Carvel began sponsoring the adorable and memorable Little Miss Half Pint Beauty Contests for little girls under the age of six. Many of the franchised locations served as registration locations for the contest.

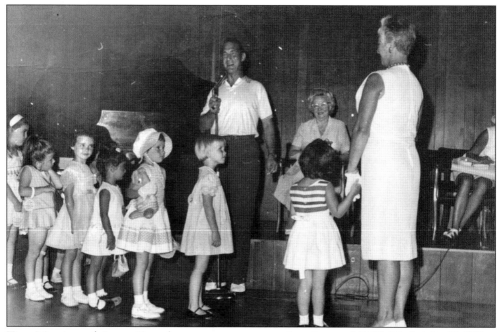

Tony Marvin and Agnes Carvel prepare to announce the winner of 1963's Little Miss Half Pint competition. The winner, little miss Sue Townsend, is third from the front of the line.

58

By 1978, more than 15,000 little girls competed in the contest.

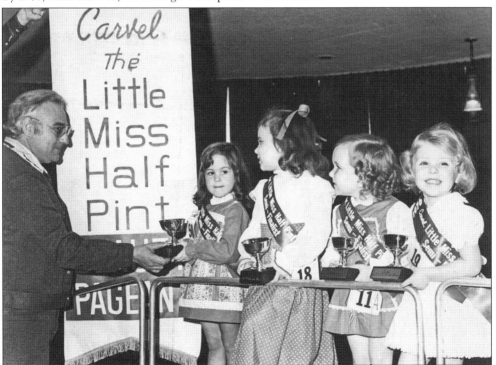

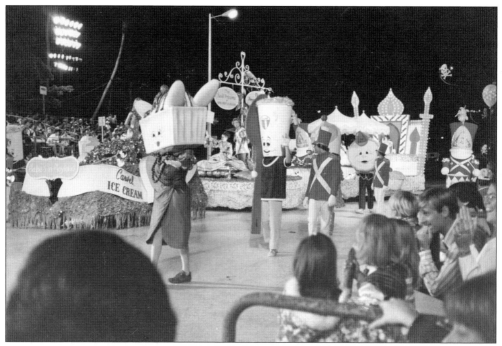

Carvel had a public relations department that managed projects like the St. Jude Children's Research Hospital telethon and fund-raising and Carvel's participation in the Pocono 500 auto race. One year, they even helped launch a Carvel Ice Cream parade.

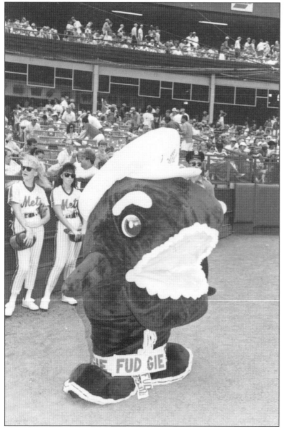

Additionally, Carvel sponsored Walt Disney's "Great Ice Odyssey," hosted "Carvel Night at the Rodeo," and participated in several promotions with the New York Yankees and the Mets.

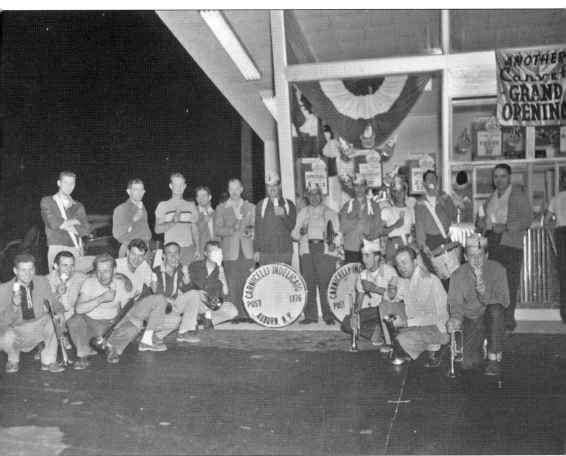

While sponsorships and citywide events were great for brand awareness, grand opening celebrations offered an opportunity to create excitement around the individual locations. Franchisees were encouraged to involve their communities and create an atmosphere full of life and energy. A marching band played in the parking lot during this grand opening celebration in Auburn, New York.

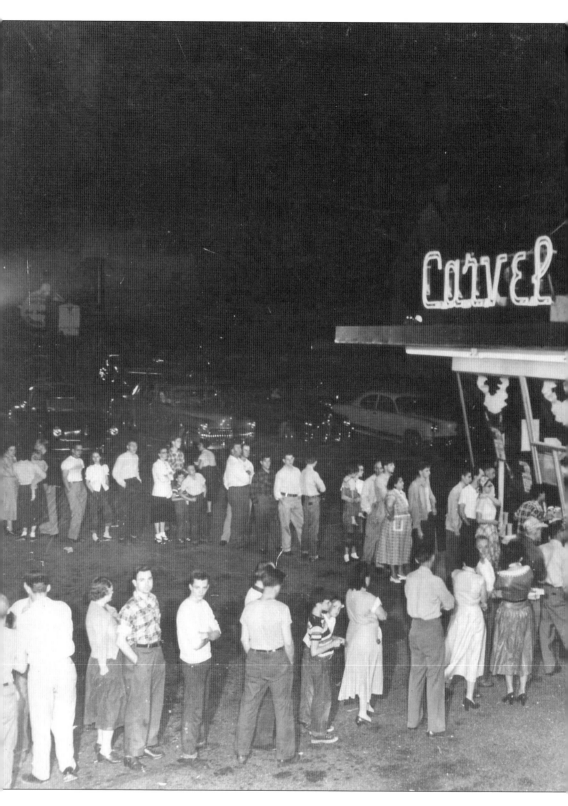

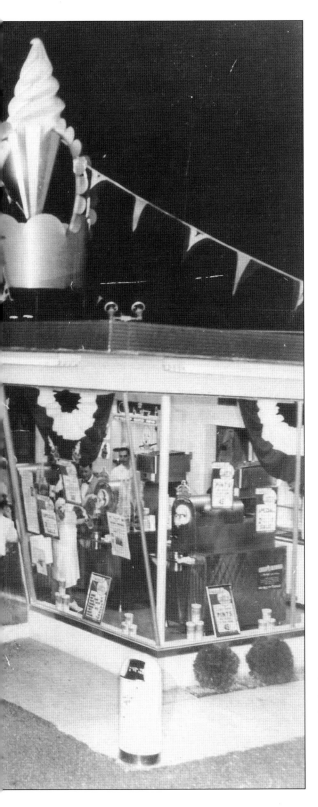

Entertainment such as live music was often necessary in order to keep patrons waiting in line happy. Lines like this one were not unusual on grand opening days. Here the crowd remains steady throughout the evening as the owners do their best to serve guests as quickly as possible.

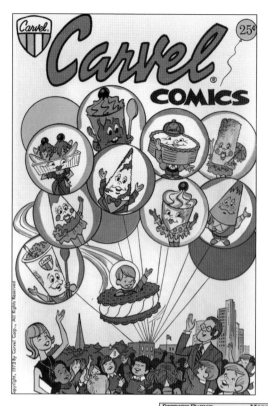

Once they had a firm grip on print, radio, and television advertising and public relations, Carvel tried its hand at some initiatives that were even further "outside of the box." In 1973, they created Carvel comic books featuring Captain Carvel, Freezy the Talking Cake, Mikey Icy Wycy, and many other Carvel characters. Each edition featured Carvel advertisements, and the book was sprinkled with "product placements" in the puzzles and games throughout.

Additionally, Carvel had its own NBA trading cards. Ten trading cards came with two coupons. While not as popular or well known as some of the other marketing tactics, it was a creative way to connect with its young male fan base.

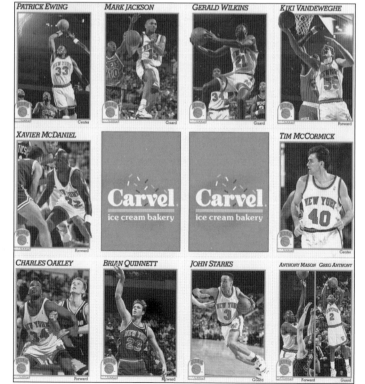

Creative marketing continued under new leadership after Tom Carvel passed. In 2002, Carvel set the *Guinness World Record* for the Largest Ice Cream Scoop Pyramid.

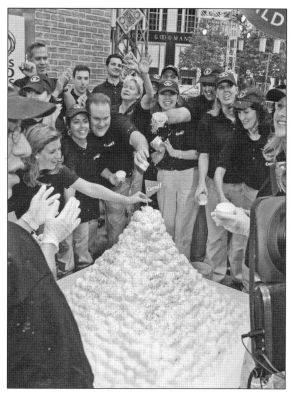

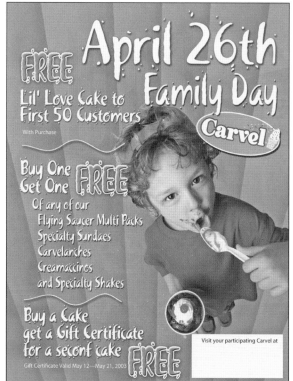

In 2003, the company brought back a Tom Carvel promotion called "Family Day." The campaign included nostalgic elements such as re-airing the old Carvel radio advertisements to connect with some of the brand's longtime fans.

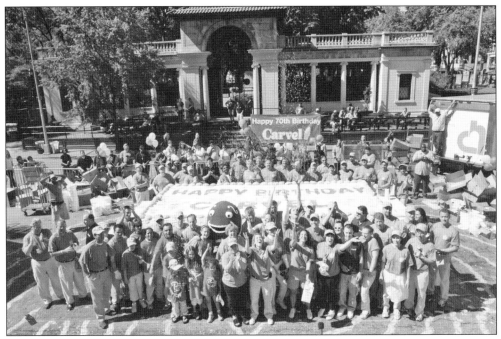

In 2004, Carvel built the World's Largest Cake to celebrate the brand's 70th birthday and set another *Guinness World Record*. Franchisees, crew members, and corporate associates worked together to create history in the middle of New York.

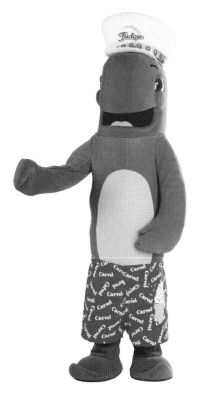

Capitalizing on the popularity of the Fudgie the Whale cake, the company brought the character to life and named him the official "spokeswhale" in 2007.

Four

THE FATHER OF FRANCHISING

Tom Carvel was confident he had created the best tasting, highest quality premium ice cream, and he felt certain he had developed the most efficient and comprehensive machinery in the industry. His final challenge was to grow his brand and share his ideas with as many people as possible. He was constantly approached by entrepreneurs interested in investing and growing the brand as well as loyal customers who wanted to be brand ambassadors for a living. He was even approached by Ray Kroc, a milkshake vendor at the time, who invited Tom to California to meet with brothers who had a hamburger concept. Tom declined, saying he didn't think the concept would work, and continued to focus on his ice cream business. The opportunity he declined, of course, was McDonald's. That just goes to show everything happens for a reason. Initially he thought he would sell his machinery and his ice cream mix, but he had no quality control to ensure that the overall experience withstood the Carvel standard of excellence. That is where the idea of franchising came into play. It was not enough to give people fish; he had to teach them how to fish. Thorough training became a critical part of the Carvel business. Tom taught people who were financially able and mentally willing to start a business how to do so and be successful. In a way, he had found a way to perpetuate the American dream that was instilled in him. Many of the documents, tools, procedures, and communication tactics instituted by Tom Carvel remain standard in the franchising industry today.

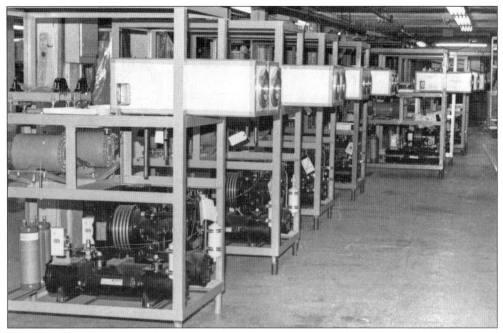

Considered by many the "Father of Franchising," Tom Carvel was the first to franchise a retail ice cream store in the United States in 1947. Initially he sold his patented freezers under the name "Custard King," but when the machine owners were not making money, he began searching for the reasons why.

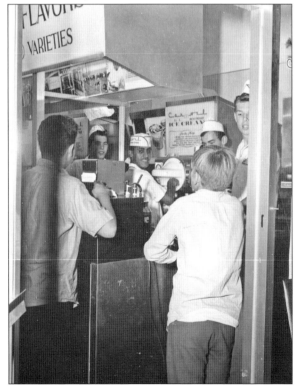

After discovering that cleanliness, location, and customer service, among other issues, were making the freezer owners unsuccessful, Tom developed a franchise model and turned the Hartsdale location into his pilot training store.

In 1950, Tom created the most complete franchise contract in the industry. In fact, it was one of the only contracts of its time to survive the Federal Trade Commission and U.S. Supreme Court.

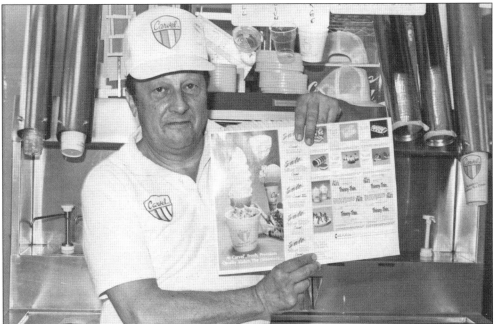

Per the franchise agreement, Carvel provided several services to the franchisees, such as training and marketing. As the franchisor, Carvel would create coupon offers and advertisements that the franchisees could customize and use. Here Vic Carnazza shows the coupon he uses for the Thinny Thin and other novelties.

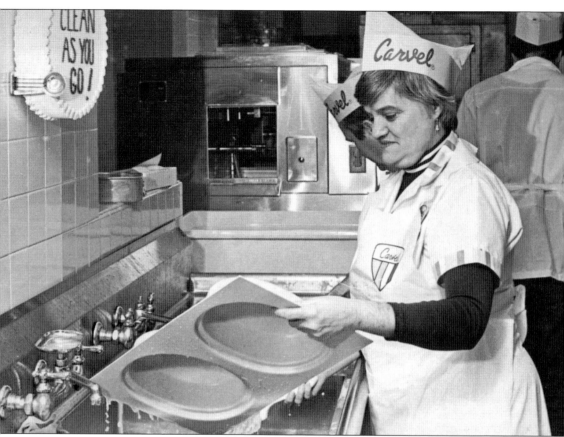

"Clean As You Go" became one of the many mantras heard throughout Carvel training. Franchisee Anna Nuzzi cleans her cake molds here in this photograph taken in January 1979.

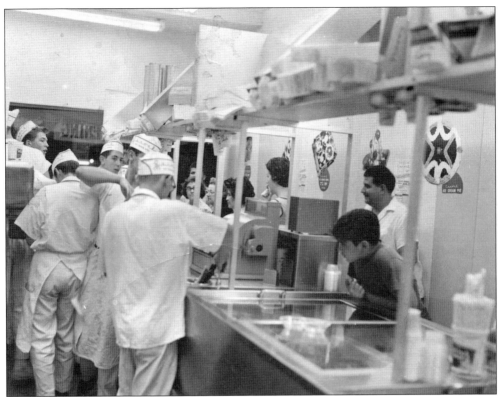

Customers expect to receive the same product and customer service at each Carvel location.
Quality control and product consistency are critical to this endeavor.

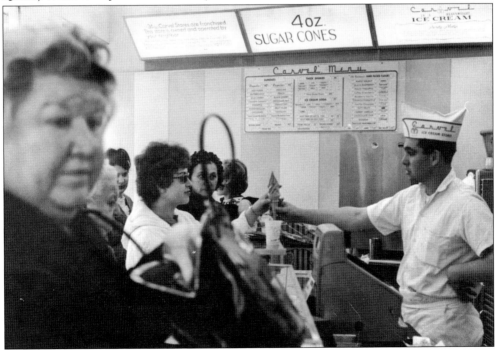

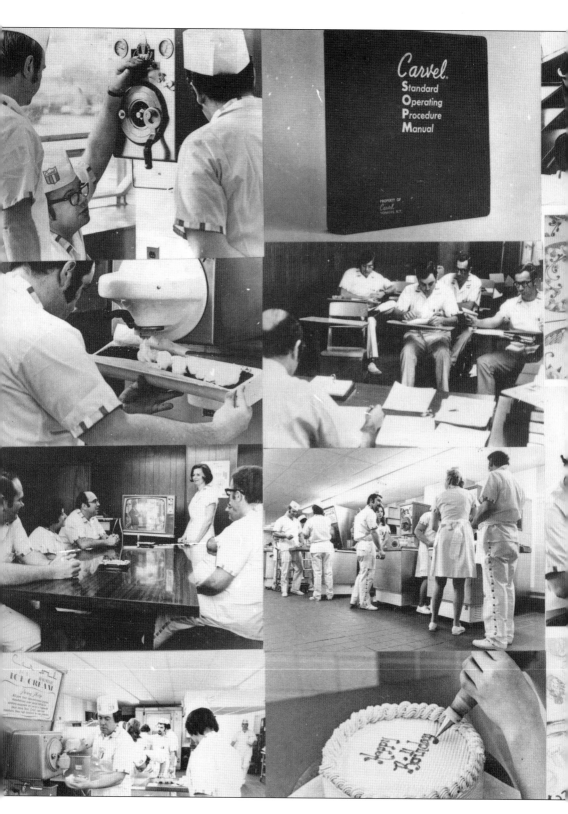

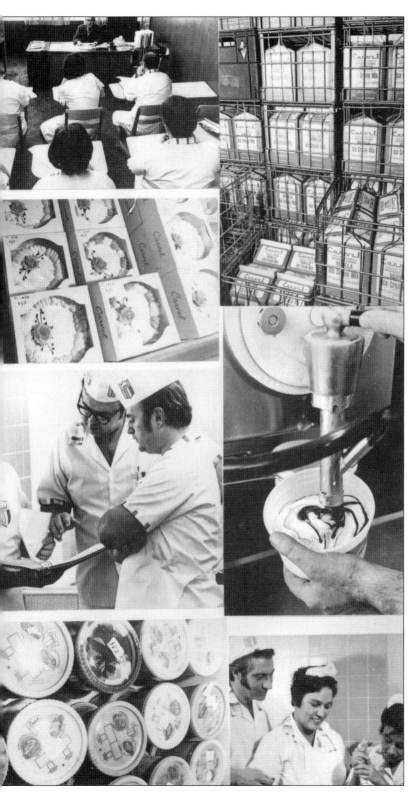

In order to help
new franchisees
understand and
embody the critical
elements of the
Carvel brand,
Tom created an
18-day franchisee
training seminar
called the "Carvel
College of Ice
Cream Knowledge."

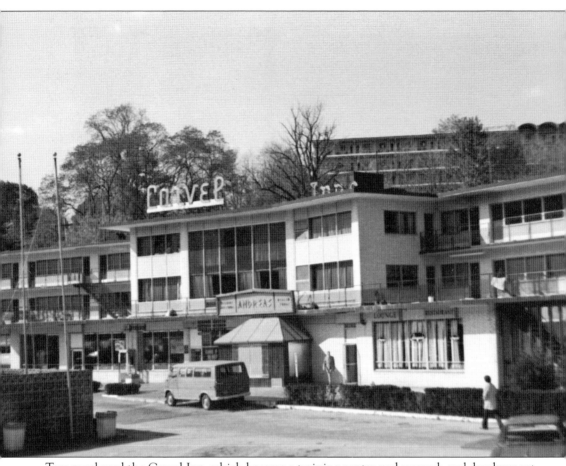

Tom purchased the Carvel Inn, which became a training center and research and development facility complete with a store counter prototype inside, ideal for training. Under new management, the hotel still stands today at 165 Tuckahoe Road in Yonkers, New York.

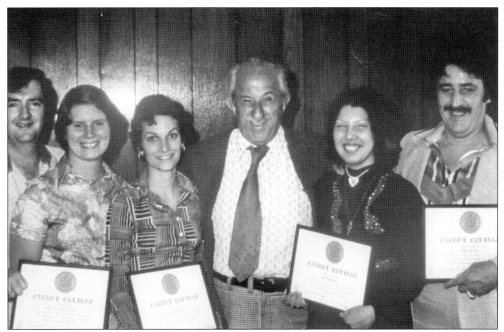

Later the training course was cut down to 14 days and renamed "Sundae School." A typical class consisted of six families listening intently to Tom sharing the stories about operating his store back in the 1930s. The emphasis was on good management, equipment maintenance, and ice cream production. Here Tom poses with a few of his proud graduates.

By 1981, the program was referred to as the Carvel School of Retail Management and covered topics such as customer service, bookkeeping, product presentation, merchandising, sales promotion, and sanitation methods, to name a few.

At the Carvel School of Retail Management graduation, Tom Carvel hosts a champagne brunch and the graduates take a photograph with Tom and their fellow attendees. Pictured are members of the graduating class of October 1982.

Tom strived for a family-like environment with franchisees who were eager to learn and willing to work hard.

Tom liked to reward those who were outstanding performers. He created the 1,000 Gallon Club to recognize those who increased their sales by 1,000 gallons of ice cream mix more than the previous year. From left to right, Glen Galente, Joseph Hoffman, Tom Carvel, Margaret Buccino, Dat Dinolfo, and Tom Carbone pose with their awards.

Another award given each year was the Clean Store Award. The winner in 1989 was Ellie Schurman, the owner of the store in Westport, Connecticut. She acquired the location from her father and started working in the store when she was 17. She ended up staying with the company for more than 50 years.

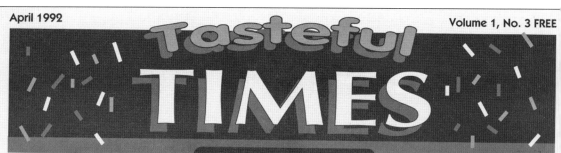

April 1992

Volume 1, No. 3 FREE

Tasteful TIMES

The Official Newsletter of CLUB Carvel

Think fast!

Do you remember what you had for lunch yesterday?

How about where you went for your birthday last year?

Without looking, do you know what color socks you're wearing?

The common problem most Americans face is the retention of information. There's just too much for the average individual to absorb and therefore we all go through a process of "filtering out" what we each think is not important. For example, over 70% of the people interviewed in a recent survey could not correctly respond to the question of "what color their car inspection sticker was". Do you know what color your car inspection sticker is?

These days most of us can never find time to remember the details. The questions below will show you what we mean.

By the way, something you should make sure to remember is that this newsletter contains some unbelievable savings for you to take advantage of at your neighborhood Carvel Ice Cream Bakery.

Now that's one piece of information definitely worth retaining.

1) On a quarter, which way does George Washington face?
2) In a deck of cards, which ace is actually different?
3) Which color is at the bottom of the traffic light?
4) What is the lowest number on an AM radio dial?
5) How many stripes are there on the American flag?

6) How many fingers does Mickey Mouse have on one hand?
7) How many circles are there in the Olympic logo?
8) How many Community Chest spaces are there in Monopoly?
9) How many matches are in an average book of matches?
10) In which hand does the Statue of Liberty hold the torch?

Look inside for the answers and more fun for the entire family.

Communication was another promise made under the franchise agreement. Internal newsletters were a major vehicle for sharing information on a frequent and consistent basis. One of the first newsletters was "The Shopper's Road," followed by the "Carvelog," "Tasteful Times," and "Sundae Times," among others.

NEWS FROM THE
CARVEL FAMILY
OF STORES

PUBLISHED
EVERY
MONTH

The Carvel Way

VOL. 1 . . . No. 1 THE CARVEL WAY DECEMBER, 1972

PRESIDENT NIXON VISITS CARVEL

President Nixon exemplified his impeccable taste during a recent visit to Florida. After dining in a fashionable Coral Gables restaurant, the President decided on an ice cream sundae for dessert. His entourage drove to the Carvel store of Peter and Lorraine Bleustein in Miami. There, the President enjoyed a coconut sundae, to his delight, as well as that of the Bleusteins. Mr. Nixon has been a long time patron of Carvel. We are honored by the President's visit, and thrilled with his loyalty to Carvel products. What the palate joins together, the Presidency shall not put asunder.

President Nixon

PRESIDENT PLEASED BY PRESIDENT'S VISIT

President Thomas Carvel expressed his pleasure upon being notified of President Richard Nixon's visit to Carvel. Mr. Carvel reminisced that this was not Mr. Nixon's

Thomas Carvel

first exposure to Carvel products. The President was reported to have visited another Carvel store in Florida on a previous trip. Long before he resided in the White House, Mr. Nixon was a habitué of Carvel. T.C. noted that over the years, many luminaries have been customers of Carvel, but the patronage of President Nixon merits special attention. You're number one with us too, Mr. President!

Around The Globe

Richard Nixon's visit to Carvel in Florida, and his choice of a coconut sundae, has raised some international eyebrows. Here are some typical comments:

Golda Meir—"I'm glad to hear he's eating Kosher food!"

Chairman Mao—"When I go to Carvel on Mott Street, I'll try the same thing."

Continued next column (bottom)

President Makes An Eating Foray

For dinner it was stone crabs, broiled pompano, crabmeat pate and Barton and Gustier chablis, vintage 1969, in a Coral Gables restaurant. For dessert it was a coconut sundae at a drive-in ice cream stand on Coral Way.

Between courses, President Nixon won the applause of his fellow diners at The Hasta, where in dined in one of his infrequent trips out of the Key Biscayne compound.

NIXON TRAVELED with his longtime Florida companion, C.G. (Bebe) Rebozo, and presidential assistant Charles Colson to the restaurant and, after dinner, to the nearby Carvel stand on a presidential whim.

There, he chatted with passersby while Rebozo stood in line to buy the sundaes.

"We used to have some pull in here," Rebozo said. He said the stand was one of Nixon's favorites when Nixon was vice president.

Rebozo got tired of standing in line and passed in $3 to an aide with instructions to

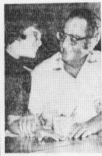

Peter Bleustein and Son, Ross. . . . excited by President's visit.

buy three sundaes and to tell the counter girl to keep the change.

NIXON, MEANWHILE, was telling a passing Cuban woman: "The Cubans are great people—good, strong, loyal people."

Peter Bleustein, 43, the store's owner, said Saturday, "I was sitting in the back of the store when my girl came up to me and said 'The President is here.'

"I couldn't believe it but I went out and there he was. We had a few words; he asked me about business and I told him I voted for him and then he gave me a feltpoint pen. He told me to write a lot of checks with it but don't send the bills to him," Bleustein said.

"I'm no kid, he added, "but I'll say this, I was excited about meeting him."

Nixon left Bleustein, autographed a paper napkin for a child, passed out a stack of cards bearing his signature, shook a few hands and drove off into the night eating his coconut sundae.

Around The Globe *(Continued)*

Queen Elizabeth—"I'll bet he forgot to enter the Pony Contest."

Mrs. Ghandi—"Mahatma was hooked on Icy-Wycys."

Premier Kosygin—"Tom Carvel promised to make Red Vanilla for me."

George McGovern—"Next time I'll skip the knishes and have a Banana Barge."

Ambassador to Iceland—"It's snowballs for me, every time."

President Celio (Switzerland)—"I'm still partial to Nougat Suisse."

Vatican—"Coconut Sundae, the makings of another holy day."

The most recent version is still used today and is called "The Carvel Way." This is an issue from December 1972.

Face-to-face communication remained critical as well. Therefore, beginning in 1950, the company would host a convention in New York to gather all of the franchisees and corporate employees to discuss various areas of business. The first one was held at the Hotel Pennsylvania, now called Statler Hilton, on October 7, 1950, and there were only 10 store owners in attendance.

Tom's nephew Stan Townsend (left) and corporate store supervisor Gaston Lemieux (right) get ready for the convention at the Park Sheraton Hotel in 1956.

Here Jerry Carvel, Tom's brother, who was working in the sales and promotions department at the time, is preparing for the big convention in 1959.

Over the years, attendance grew and so did the conference agenda. The convention would include Area Educational Seminars to provide continuing education for existing franchisees, covering topics such as business fundamentals, advertising, marketing, and product knowledge.

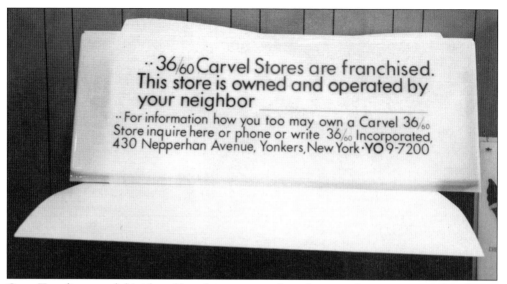

Once Tom discovered this idea of franchising was working, he wanted to attract more franchisees and worked to promote the fact that Carvel was a franchise system. Many locations displayed this sign to attract new owners.

Many franchisees found that one of the perks of working for an ice cream shop is the family time it had to offer. Many business owners were husband/wife duos, and many of those passed their business along to their children. Here Al Angelini pours soft serve with his wife, Diane, at their store.

Franchisee Zaya Givargidze joined the company as a teenager and still operates locations in New York. His business has been a family affair for more than 30 years.

Here franchisee Frank Auriemma stands with Tom. Frank was 17 years old when he purchased his first Carvel franchise, and Tom took him under his wing and treated him like a son. According to Frank, who has three locations opened today, Tom believed in him and gave him great advice, which lent to his success.

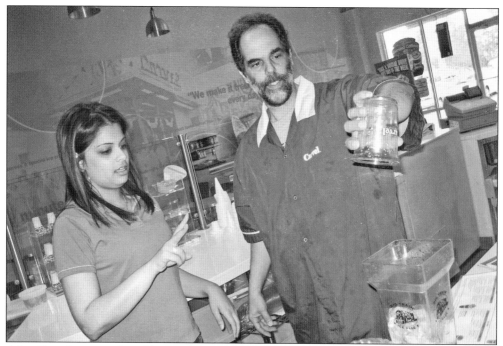

After Carvel was purchased by Roark Capital Group in 2001, new leadership wanted to continue the emphasis of ongoing, hands-on training and implemented a biannual initiative called "Refresh Our Image" or ROI. The company sent a representative to each store to train on new products and refresh in-store creative elements.

The company also continued to host biannual conferences as well as regional meetings to continue the facilitation of idea sharing and fellowship among the franchisees.

Five

GROWING ACROSS
AMERICA

Franchising was catching on. With explosive growth came new challenges. As is true today, good real estate was vital to the success of a store. The brand name was spreading quickly but was very concentrated in New York and South Florida. As business in general was booming, it became increasingly difficult to snatch up the most desirable real estate, particularly in new markets. Another challenge was meeting the needs of each franchisee. Ongoing training, grand opening support, quality control, and marketing became more difficult as the business grew. With each opening, they had to get bigger and even more creative. Despite some of the growing pains, Carvel grand opening celebrations continued to draw enormous crowds from miles around.

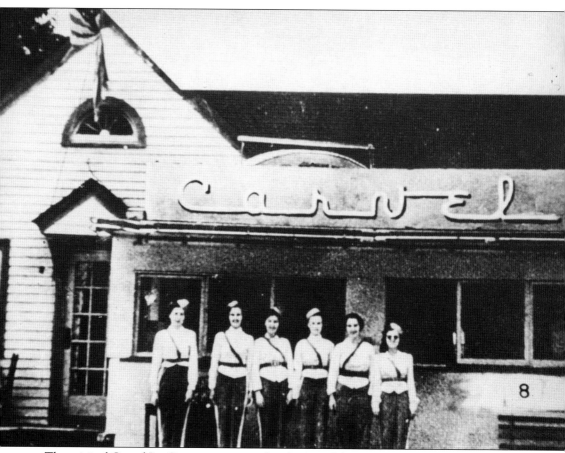

The original Carvel Ice Cream store opened at the site of the old pottery store in Hartsdale, New York, in 1936. However, in 1956, it was converted to a more modern design and reopened as the world's first Carvel Ice Cream Supermarket. Here the curb girls pose for a photograph in front of the Hartsdale location.

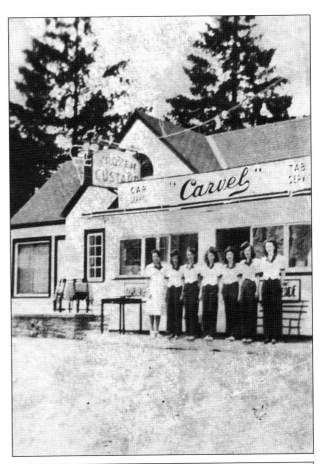

This is the original location along with the press release announcing the re–grand opening. This opening attracted over 23,000 people who saw live performances from five bands from the time it opened until 2:00 a.m.

 ® CORPORATION

201 SAW MILL RIVER ROAD
YONKERS, NEW YORK 10701
(914) 969-7200

FOR IMMEDIATE RELEASE

CONTACT: Katrinka Walter

The first Carvel ice cream store, built on the site of a pottery shop on Central Avenue in Hartsdale, NY. The scene is mid-thirties, a Carvel sign has been added; and the number of carhops has swelled to seven, including Mrs. (Agnes) Carvel who stands on the left.

#

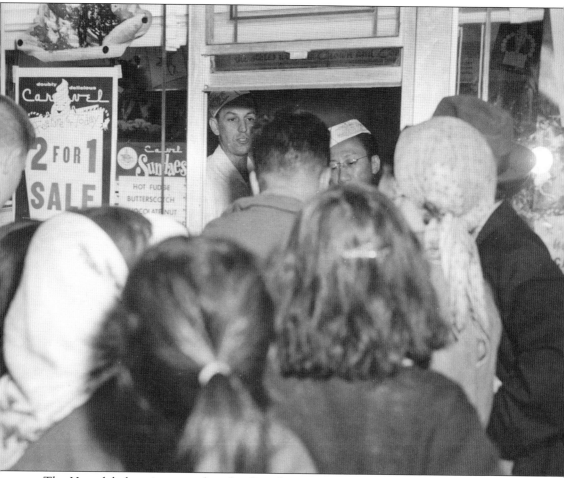

The Hartsdale location served as the Carvel training store from 1948 until 1970, when the company opened the Carvel Inn in Yonkers, New York.

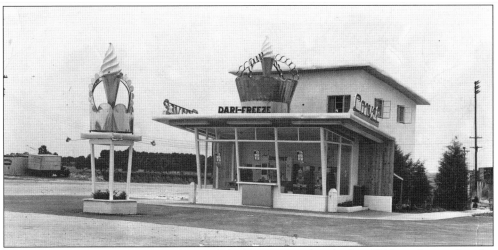

Drive-in locations, like the original Hartsdale design, started in the late 1930s and existed in the Carvel chain for years under the name Carvel Dari-Freeze.

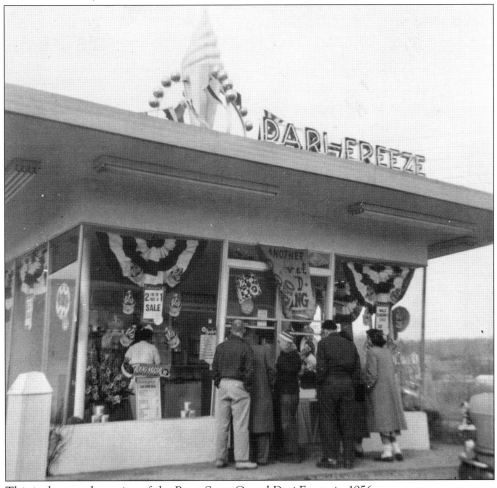

This is the grand opening of the Penn State Carvel Dari-Freeze in 1956.

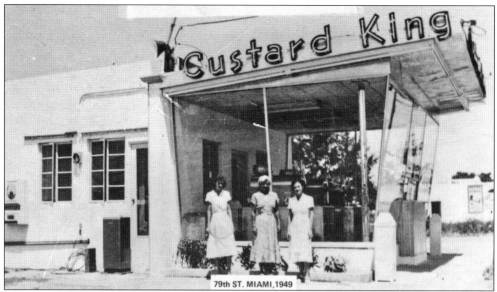

In 1946, when the "Custard King" ice cream machines were released, many of the drive-in storefronts read "Custard King" as opposed to Carvel or Dari-Freeze.

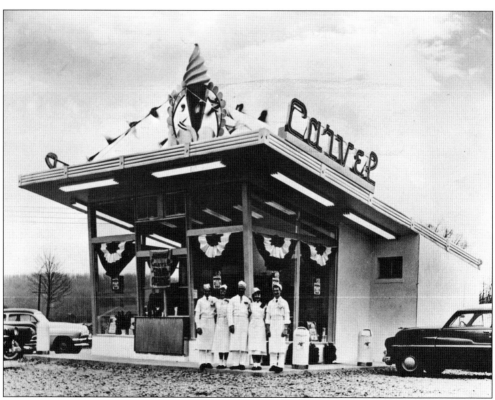

In 1947, Carvel patented an all-glass-front building with a pitched roof to be the design for its stand-alone locations. Later this design was copied by several restaurants, including McDonald's.

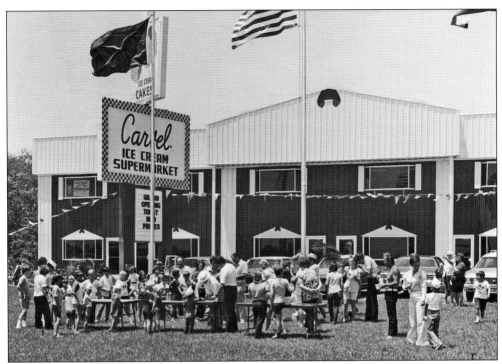

Carvel Supermarkets, which became the prototype for more than 400 locations, were essentially the retail stores under a new name.

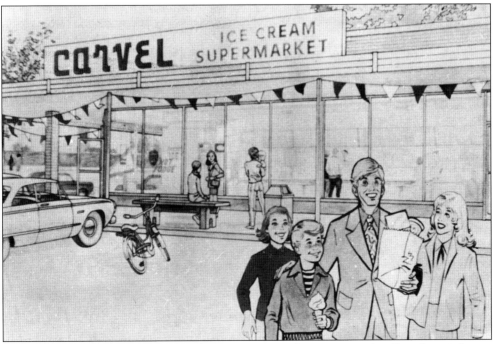

The concept of an ice cream "supermarket" communicated to customers that Carvel carried more than just ice cream cones. The brand resonated with consumers as a one-stop shop for a variety of desserts, including cakes, fountain items, and ice cream novelties.

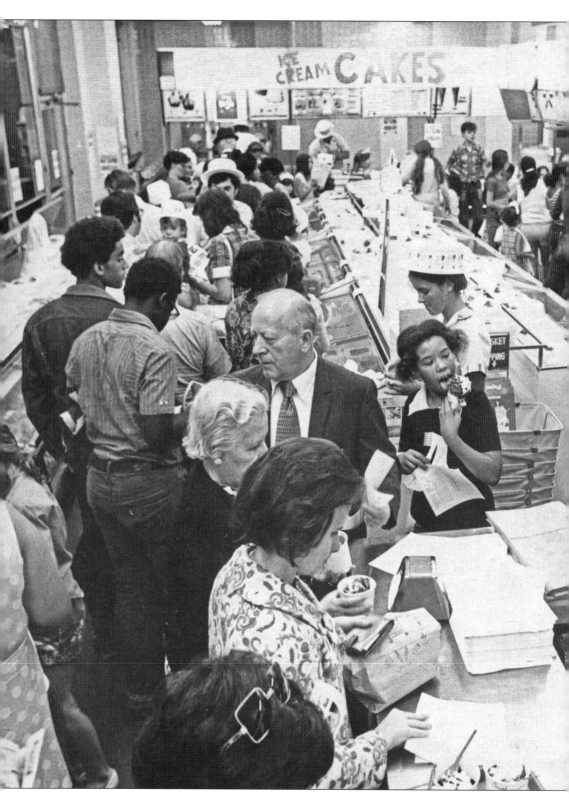

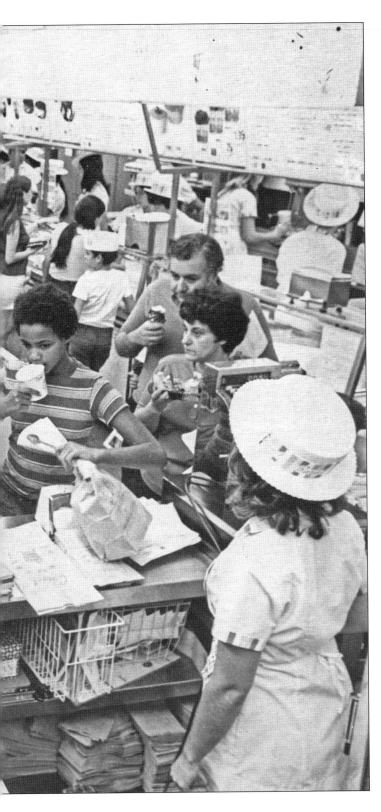

Another prototype was the Carvel Ice Cream Factory. It produced ice cream cakes and novelties for itself and for nearby satellite locations.

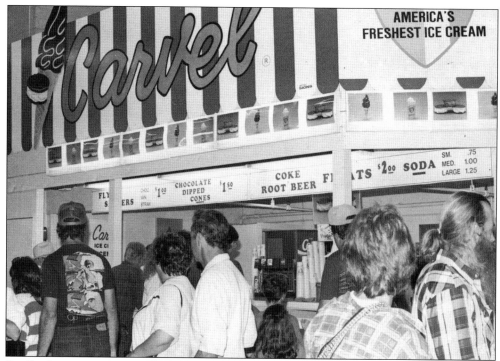

AMERICA'S
FRESHEST ICE CREAM

Satellite locations were a smaller footprint in high-traffic areas. In order to offer the same products as supermarkets and factories, satellite locations relied on the nearest factory location for product.

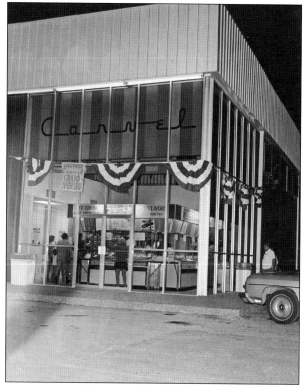

The 36/60 concept was developed in 1959. This prototype did not carry the full line of Carvel products like the other Carvel locations. It simply carried 36 flavors and 60 varieties of ice cream, which called for a smaller site and less product.

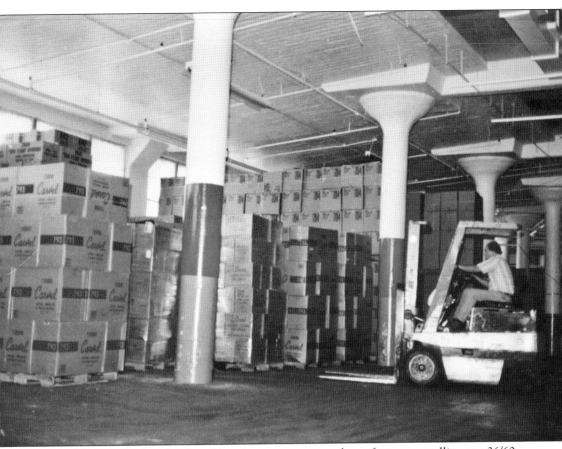

However, despite whether the Carvel location was a supermarket, a factory, a satellite, or a 36/60, the equipment and products were distributed from the facility at 201 Sawmill Road in Yonkers, New York, and all equipment was produced just down the street at 430 Nepperhan Avenue.

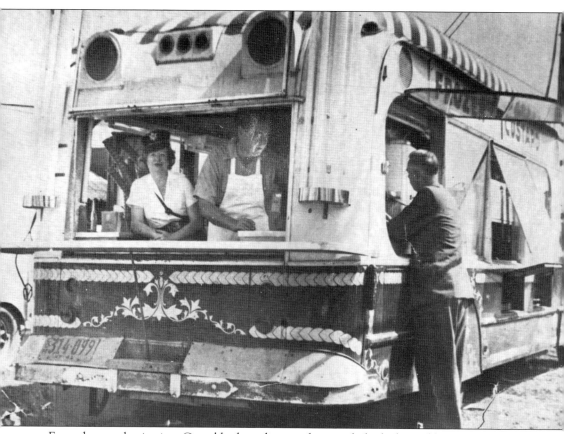

From the very beginning, Carvel had vending trucks out of which they sold ice cream.

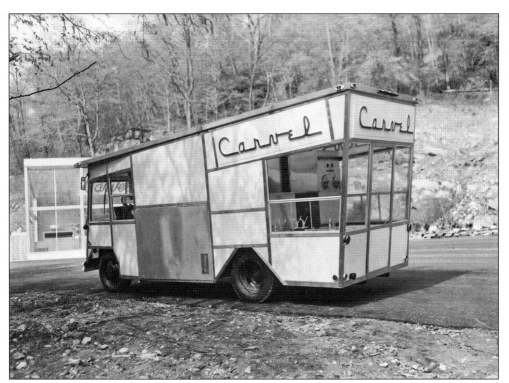

The vending trucks continued to evolve over the years.

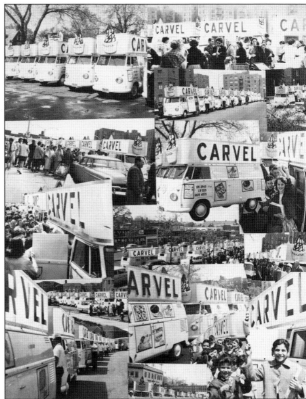

Vending trucks were often seen at festivals throughout the Northeast.

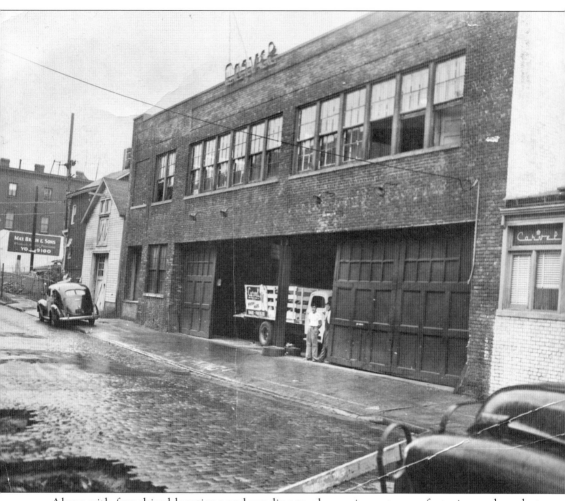

Along with franchised locations and vending trucks, equipment manufacturing and product distribution was a part of the Carvel business. Tom manufactured his patented ice cream machinery and distributed his patented product from his own facility in Yonkers, New York, which opened in 1955.

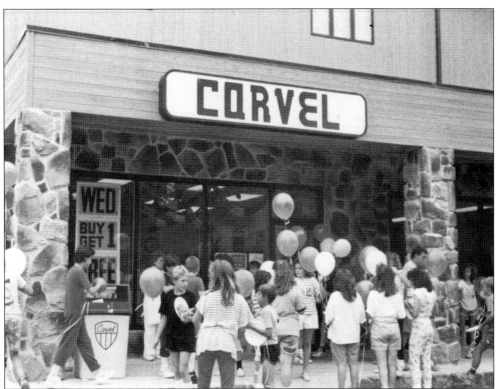

Carvel franchise locations are the lifeline of the brand. Each grand opening was, and still is, a pivotal part of the business and typically created a great deal of attention.

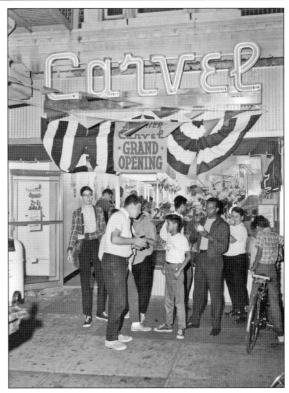

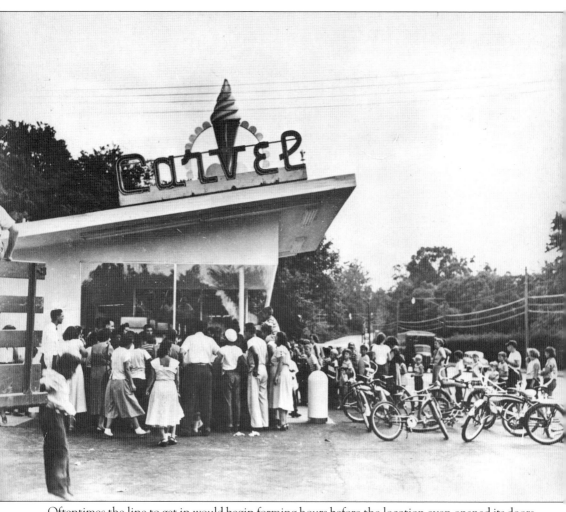

Oftentimes the line to get in would begin forming hours before the location even opened its doors. It became an event in and of itself to anticipate the opening with fellow Carvel fans.

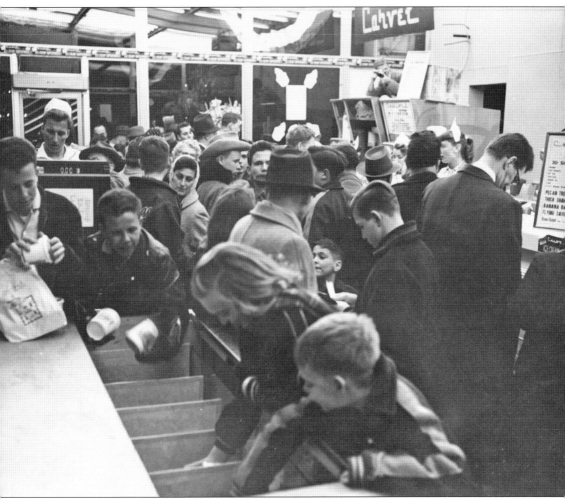

Once the doors opened, Carvel fans clamored to get their hands on America's Freshest Ice Cream.

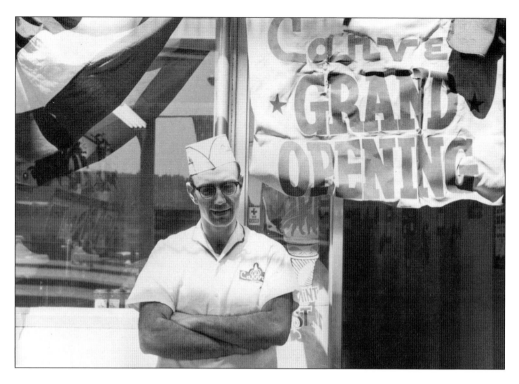

Neighborhoods would get excited every time they saw the famous "Another Carvel Grand Opening" sign.

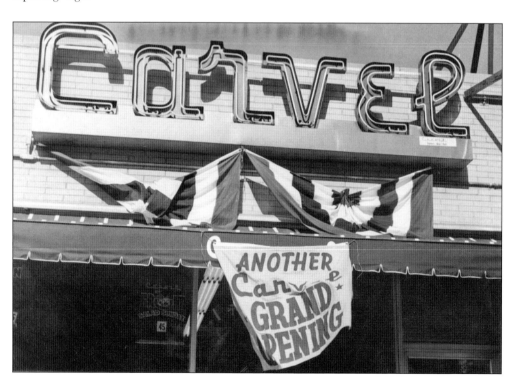

Many store openings included marching bands, special prices or offers, major signage including inflatable signs and banners, and some even had face painters and clowns for the kids.

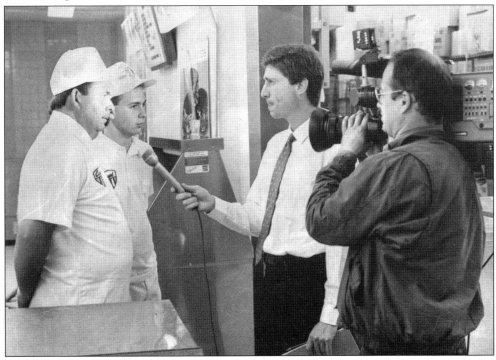

At this opening, the CNBC crew interviews owner Daniel Mello and his son Greg Mello for the local news.

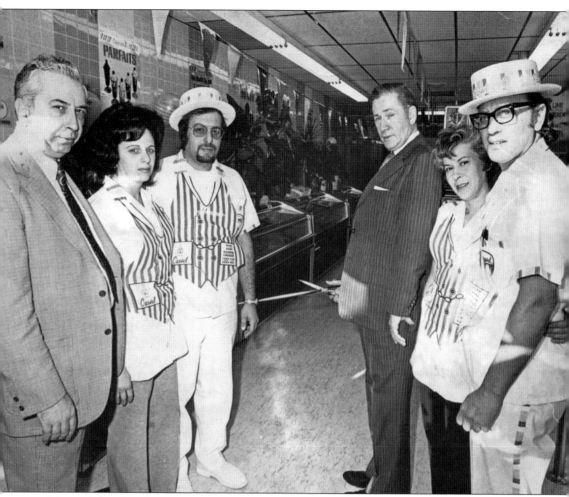

Many of the store opening tactics were designed to attract the media. Here the mayor of West New York cuts the ribbon to signify the opening of the newest Carvel in 1971. Photographs like these often ended up in the local papers.

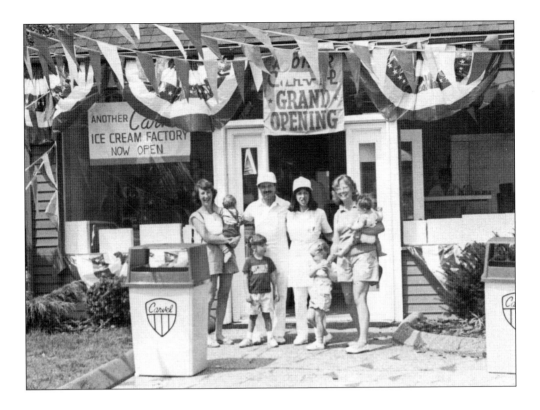

Even if the media did not recognize the opening, Carvel would celebrate openings internally via the "Carvel Way" newsletter and would sometimes include captions and photographs from the latest openings.

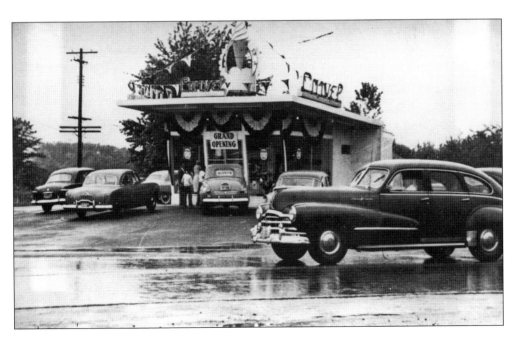

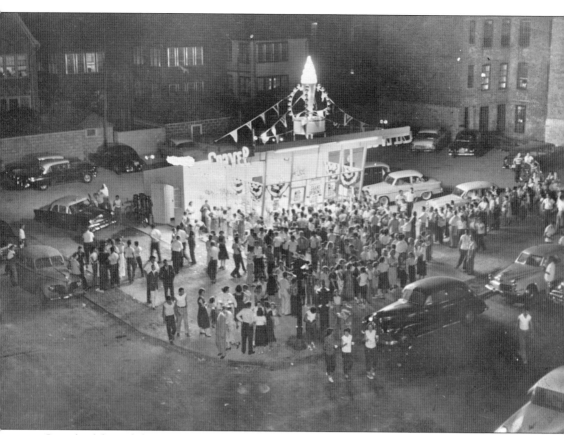

Carvel celebrated the opening of its 100th store in 1951.

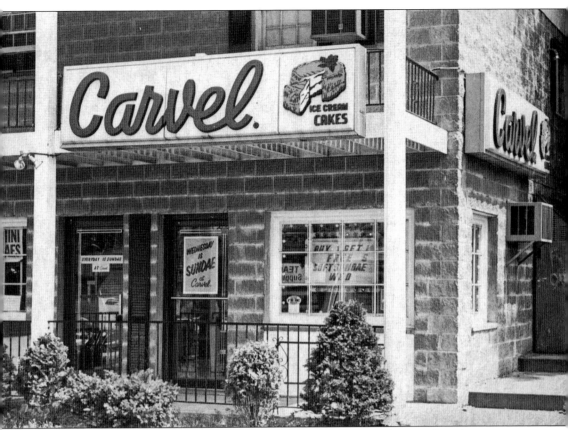

As Carvel grew, building stand-alone locations with the glass storefront each and every time became increasingly difficult. Carvel found itself in buildings of all shapes and sizes, including strip centers.

A Carvel Ice Cream Store could even be found in the Carvel Inn in Yonkers.

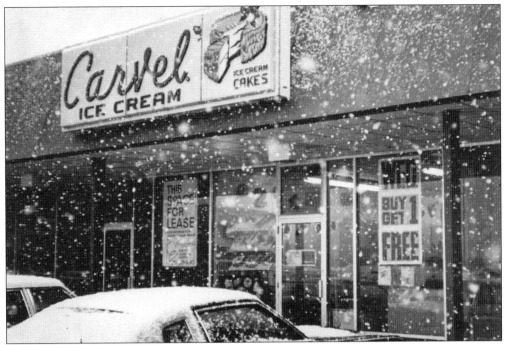

Seasonality was a challenge for Carvel. In the cold months, people tend to come in less often for their weekly ice cream cone. However, holiday cakes remained a major part of their business regardless of the weather.

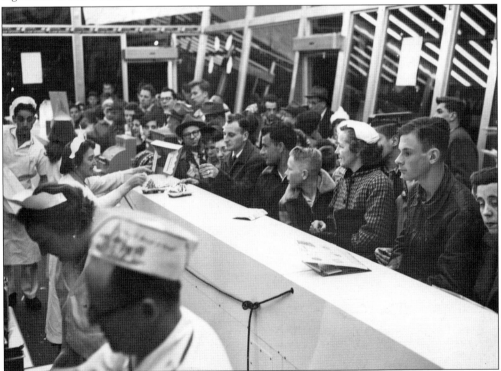

Despite any challenges the brand faced, at its highest point it had more than 900 locations.

With fast growth came the need to outsource distribution. For many years, Carvel had its own distribution system to serve its franchisees. Carvel distribution trucks are pictured above, and pictured below is the Carvel distribution facility.

As Tom grew older, he realized it was time to turn the company over to new leadership. He sold the company to Investcorp in 1989, one year before he passed away.

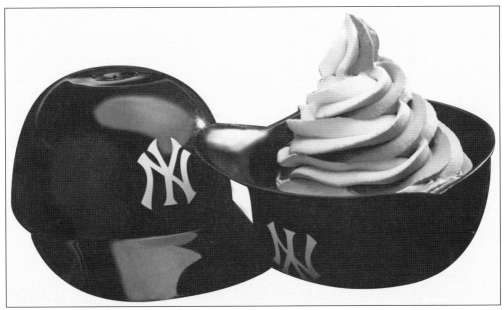

In 1993, the company developed a multi-pronged distribution business model including retail shops, stadiums, super club stores, and supermarkets.

In 1998, the company began a manufacturing division, placing Carvel-branded freezers and products in 4,500 grocery stores nationwide.

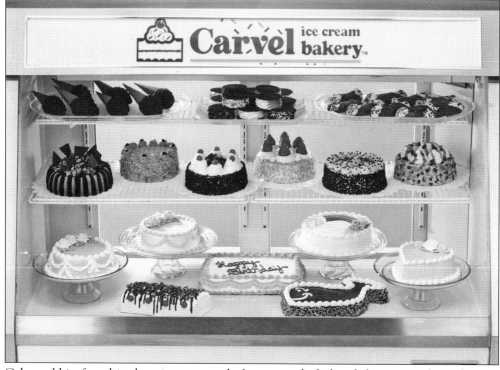

Cakes sold in franchise locations are made from scratch daily, while supermarket cakes are produced through Carvel's manufacturing division.

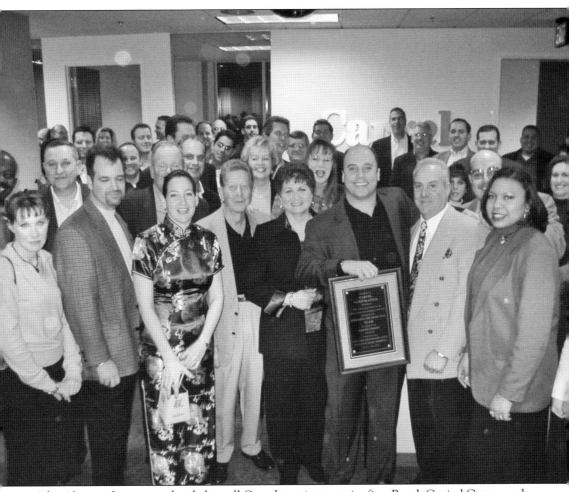

After 12 years, Investcorp decided to sell Carvel to private equity firm Roark Capital Group, and the company was relocated to Atlanta, Georgia.

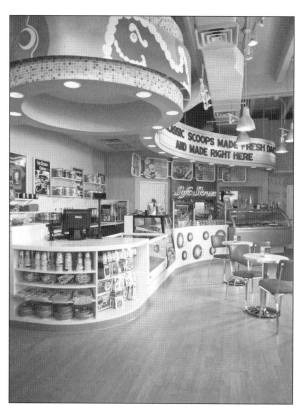

In 2003, new management created a new store prototype and opened the first location in Vero Beach, Florida. Some new features included the famed Sprinkle Tour and updated in-store signage.

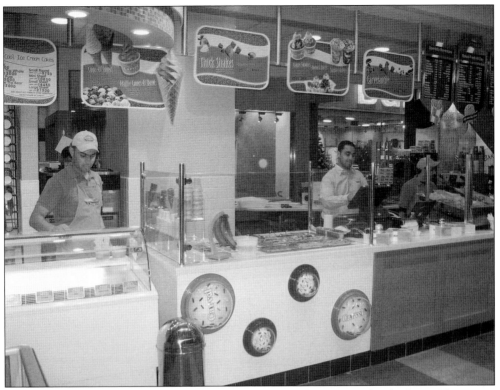

The new Carvel leadership rejuvenated international growth. By 2008, they had over 40 overseas locations, including this one in Jordan.

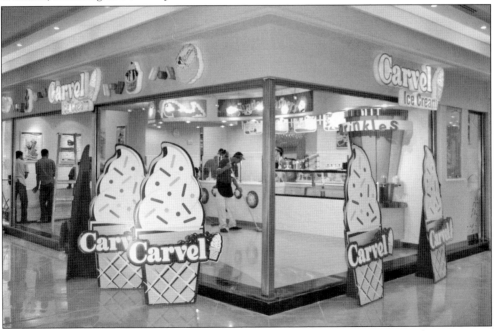

While Carvel has experienced most of its international growth in Puerto Rico, it also has a presence in the Middle East and in South America. Here is a photograph of a Carvel location in Egypt.

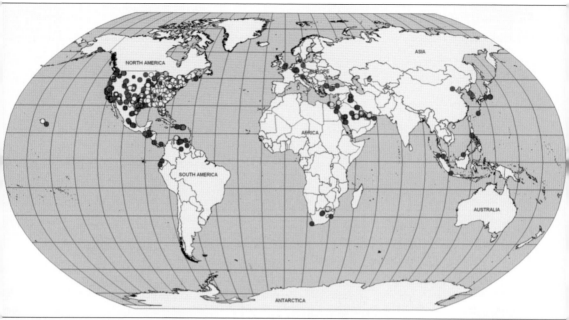

In 2004, the Carvel Corporation joined forces with Cinnabon and Seattle's Best Coffee International to create FOCUS Brands. Over the next four years, FOCUS Brands acquired Schlotzsky's and Moe's Southwest Grill. Today Carvel Ice Cream has more than 570 franchised and food-service locations serving delicious, high-quality cakes, novelties, cups, cones, sundaes, and shakes. In addition, the company sells its famous ice cream cakes through more than 10,000 supermarket outlets.

Six

REMEMBERING
75 YEARS

When Carvel Ice Cream turned 70 years old, the company's marketing and public relations department launched a memories and memorabilia campaign. Fans of all ages were encouraged to share stories and photographs of their favorite Carvel memories. Over 250 customers sent in letters throughout the two-month promotion. As expected, Carvel's dedicated following was eager to share and excited to be a part of the brand's history. Carvel fans come in all shapes and sizes—including in celebrity form. Celebrities such as Bob Hope, Ray Kroc, and Oprah Winfrey had the pleasure of knowing Tom Carvel personally, while others like Kelly Ripa are simply Carvel fans. Carvel has even been mentioned in television shows such as *How I Met Your Mother*, *The Family Guy*, and *The Office*, further immersing the brand in American history and pop culture. This chapter is a tribute to Carvel fans and those who have supported and loved the brand over the years.

RICHARD NIXON

October 24, 1990

577 CHESTNUT RIDGE ROAD
WOODCLIFF LAKE, NEW JERSEY

Dear Mrs Carvel,

When I learned on Monday of Tom's passing, I was struck by the feeling that even those who did not know him personally had lost a friend. He made people happy not only through the products he made and sold for so many years, but anyone who ever saw his television commercials or listened to his radio advertisements felt as though they knew Tom. His business and marketing genius will be sorely missed but long remembered.

Pat joins me in extending our deepest sympathy to you.

Sincerely,

Mrs. Tom Carvel

"Dear Mrs. Carvel: When I learned on Monday of Tom's passing, I was struck by the feeling that even those who did not know him personally had lost a friend." —Richard Nixon

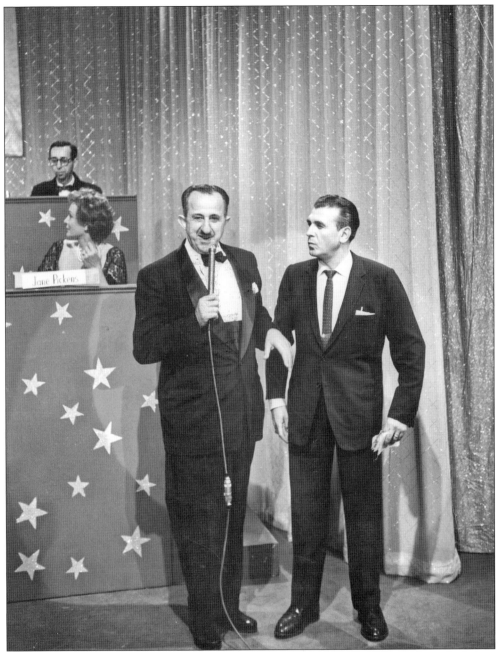

Two pioneers in their respective industries, Tom Carvel and Dennis James, host a televised telethon in 1979. Dennis James was an actor, talk show host, game show host, wrestling announcer, and newsreel announcer in the 1970s.

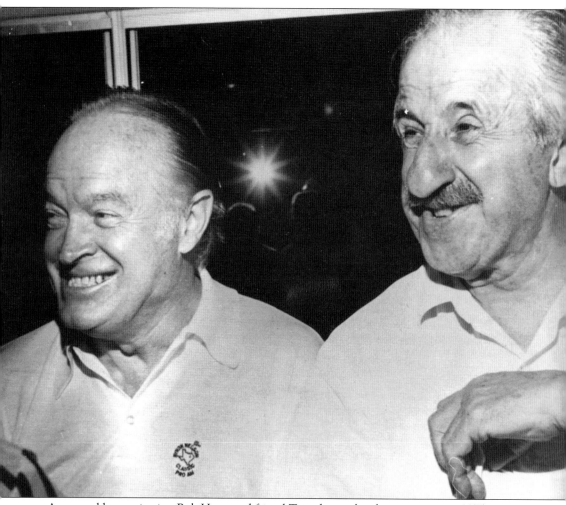

Actor and humanitarian Bob Hope and friend Tom share a laugh at an event in 1975.

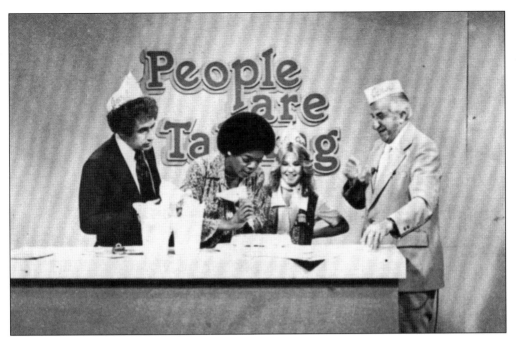

Tom was Oprah Winfrey's first interview guest for *People Are Talking* on Baltimore's WJZ-TV. Oprah is pictured here decorating her very own Carvel cake while Tom coaches from the side.

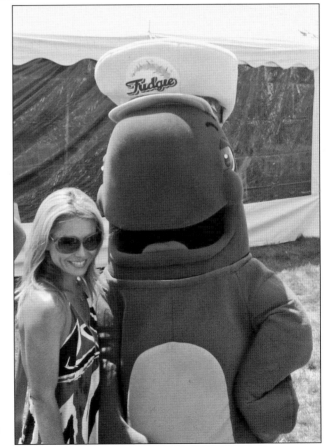

Kelly Ripa meets Fudgie the spokeswhale at an event to benefit the Ovarian Cancer Research Fund in the Hamptons, New York, in 2008.

"Father's Day, 1987: The Carvel cake made the day so special as I remembered taking this picture 17 years ago and had no problem locating it in the photo album as it brought back such a wonderful memory. . . . Thank you for making the day so memorable with your delicious Fudgie the Whale Ice Cream Cake! The look on my son's face says it all!" —Linda B., East Windsor, New Jersey

Any celebration in our family is always a little more special with a Carvel cake. This image is of Sandra M. of Rutherford, New Jersey, and her daughter celebrating her first birthday.

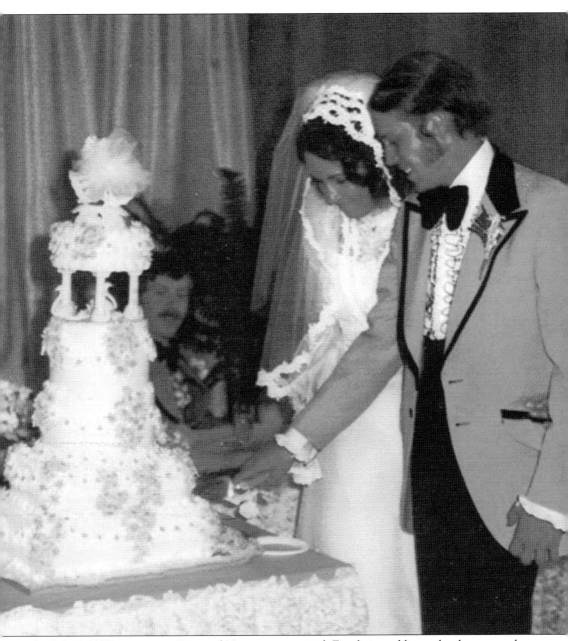

"On July 4, 1975 my parents, Don and Nancy, got married. For their wedding cake they wanted something different, but something everyone would enjoy. So, they got a Carvel Ice Cream cake. It was the first wedding cake for the New Rochelle, NY store and the whole staff came to deliver it. It made the day special because at the end of the day, there was no cake left."
—Christina K., Poughkeepsie, New York

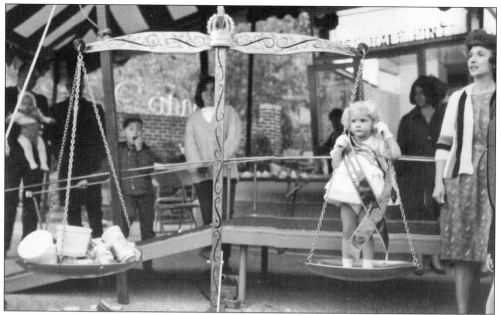

"I was two years old when I won the title of Carvel's Little Miss Half Pint. I remember fondly those memories of me being crowned and eating Carvel Ice Cream. Growing up, I lived in Brooklyn, NY and around the corner from us was a Carvel Ice Cream parlor. It was great as I was allowed to walk around the corner with one of my older siblings. Sincerely, Carvel's Little Miss Half Pint of 1964." —Nancy H., Staten Island, New York

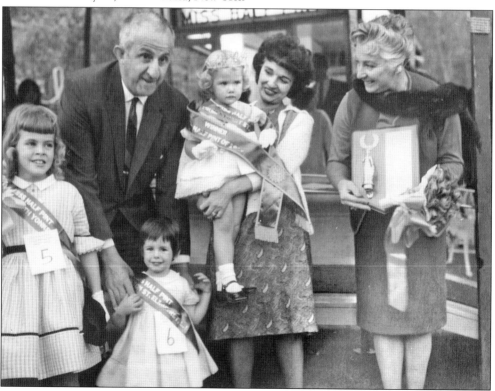

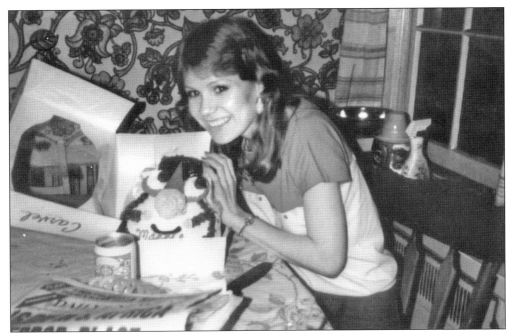

"Over the years, Carvel has always been one of our favorites for special occasions. This picture shows my sister in 1983 celebrating her 20th birthday and I was the photographer. . . . Now as a mother with three children, we have their birthday cakes as well from Carvel. Thanks for the 'tasty' memories!" —Claire R., Brooklyn, New York

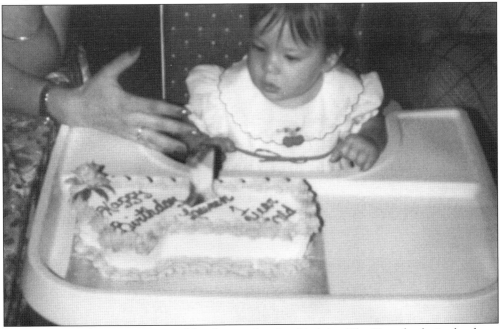

"This photo is of my youngest granddaughter on her first birthday. The Carvel cake in the shape of a number one was placed on her highchair tray and the first thing she did was stick her whole little hand and her little face right in it. She is now 18 years old and still loves Carvel cake." —Ina C., Queens Village, New York

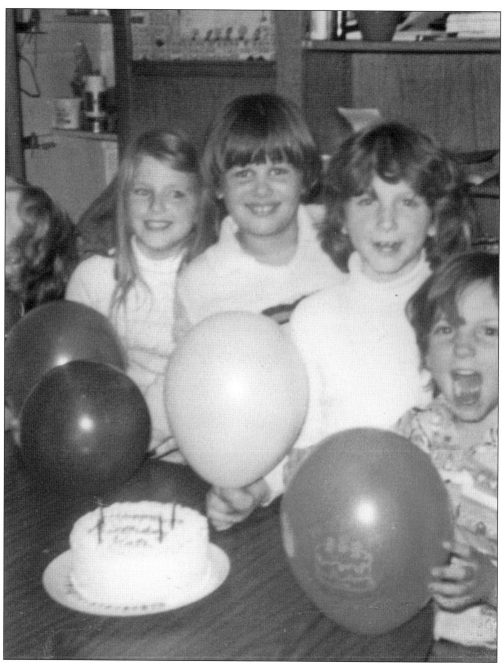

"Here is a picture of me holding a pink balloon on my ninth birthday in 1978. This birthday was special because being from a large family (three brothers and five sisters), birthdays were celebrated frequently. Everyone always wanted chocolate cake, but that year I asked my mom if I could have a Carvel Ice Cream cake for my birthday as they had just opened a shop nearby. I can still remember the taste of the green gel and chocolate 'crunchies.' I still look forward to eating Carvel Ice Cream cakes not just on birthdays, but on any occasion and of course saving the crunchies until the end. I guess my youngest brother and sister couldn't wait for their pieces of Carvel Ice Cream cake, as their mouths are wide open!" —Katie K., North Chelmsford, Massachusetts.

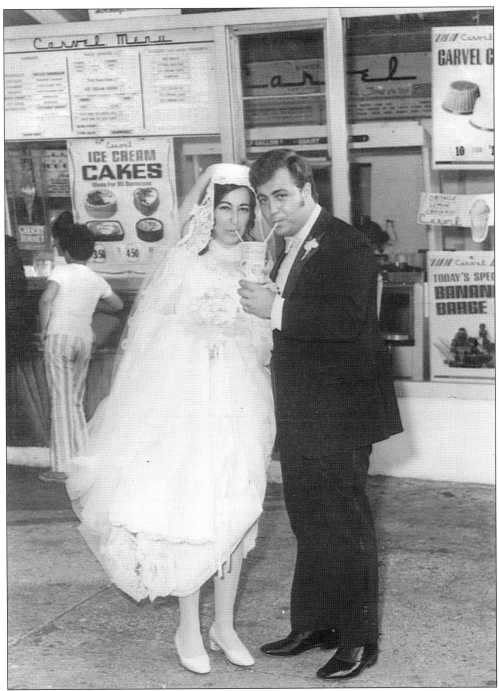

The winner of the Memories and Memorabilia promotion sent this photograph along with their story. In 1971, Brooklyn, New York's newest of newlyweds, Jerry and Rose Ann, wanted special ice cream on their special day, so they instructed their wedding limo driver and photographer to stop by Carvel so they could share a Thick Shake. This memory along with many others is now a part of 75 years worth of Carvel history. May the brand continue to thrive and spread happiness across America for years to come.

ACROSS AMERICA, PEOPLE ARE DISCOVERING SOMETHING WONDERFUL. THEIR HERITAGE.

Arcadia Publishing is the leading local history publisher in the United States. With more than 5,000 titles in print and hundreds of new titles released every year, Arcadia has extensive specialized experience chronicling the history of communities and celebrating America's hidden stories, bringing to life the people, places, and events from the past. To discover the history of other communities across the nation, please visit:

www.arcadiapublishing.com

Customized search tools allow you to find regional history books about the town where you grew up, the cities where your friends and family live, the town where your parents met, or even that retirement spot you've been dreaming about.